ARTSOURCE™

V O L U M E 1

Fantastic Activities

Created by The Church Art Works

Youth Specialties

ZondervanPublishingHouse
Grand Rapids, Michigan
A Division of HarperCollins*Publishers*

Zondervan/Youth Specialties Books

Adventure Games
Amazing Tension Getters
ArtSource™ Volume 1: Fantastic Activities
ArtSource™ Volume 2: Borders, Symbols, Holidays, & Attention Getters
Attention Grabbers for 4th-6th Graders (Get 'Em Growing)
Called to Care
The Complete Student Missions Handbook
Creative Socials and Special Events
Divorce Recovery for Teenagers
Feeding Your Forgotten Soul (Spiritual Growth for Youth Workers)
Get 'Em Talking
Good Clean Fun
Good Clean Fun, Volume 2
Great Games for 4th-6th Graders (Get 'Em Growing)
Great Ideas for Small Youth Groups
Greatest Skits on Earth
Greatest Skits on Earth, Volume 2
Growing Up in America
High School Ministry
High School TalkSheets
Holiday Ideas for Youth Groups (Revised Edition)
Hot Talks
Ideas for Social Action
Intensive Care: Helping Teenagers in Crisis
Junior High Game Nights
Junior High Ministry
Junior High TalkSheets
The Ministry of Nurture
On-Site: 40 On-Location Programs for Youth Groups
Option Plays
Organizing Your Youth Ministry
Play It! Great Games for Groups
Quick and Easy Activities for 4th-6th Graders (Get 'Em Growing)
Super Sketches for Youth Ministry
Teaching the Bible Creatively
Teaching the Truth about Sex
Tension Getters
Tension Getters II
Unsung Heroes: How to Recruit and Train Volunteer Youth Workers
Up Close and Personal: How to Build Community in Your Youth Group
Youth Ministry Nuts & Bolts
The Youth Specialties Handbook for Great Camps and Retreats
Youth Specialties Clip Art Book
Youth Specialties Clip Art Book, Volume 2

About the YOUTHSOURCE™ Publishing Group

YOUTHSOURCE™ books, tapes, videos, and other resources pool the expertise of three of the finest youth ministry resource providers in the world:

• Campus Life Books—publishers of the award-winning **Campus Life** magazine, who for nearly 50 years have helped high schoolers live Christian lives.

• Youth Specialties—serving ministers to middle school, junior high, and high school youth for over 20 years through books, magazines, and training events such as the National Youth Workers Convention.

• Zondervan Publishing House—one of the oldest, largest, and most respected evangelical Christian publishers in the world.

Campus Life
465 Gundersen Dr.
Carol Stream, IL 60188
708/260-6200

Youth Specialties
1224 Greenfield Dr.
El Cajon, CA 92021
619/440-2333

Zondervan
1415 Lake Dr. S.E.
Grand Rapids, MI 49506
616/698-6900

ArtSource™ Volume 1: Fantastic Activities

Copyright © 1991 by Youth Specialties, Inc.

Youth Specialties Books, 1224 Greenfield Drive, El Cajon, California 92021, are published by Zondervan Publishing House, 1415 Lake Drive, S.E., Grand Rapids, Michigan 49506

ISBN 0-310-53831-9

Created by David B. Adamson and J. Steven Hunt of The Church Art Works, Salem, Oregon

Printed in the United States of America

91 92 93 94 95 / ML / 10 9 8 7 6 5 4 3 2 1

TABLE OF CONTENTS

**Enter a New Era of Creativity
With ArtSource™ Computer Clip Art**

The clip art you see in this book is also available on computer! Youth Specialties and The Church Art Works invite you to try computer clip art—high-resolution art on computer disks for use with the most popular page layout programs. Each illustration is digitized into its own file for easy manipulation—stretching, squeezing, enlarging, and reducing.

Enjoy the advantages of creating the electronic way—with ArtSource™ computer clip art.

COLLECT THE ENTIRE ARTSOURCE™ COMPUTER CLIP ART SERIES:
 Volume 1—Fantastic Activities
 Volume 2—Borders, Symbols, Holidays, & Attention Getters
 Volume 3—Sports
 Volume 4—Phrases & Verses
 Volume 5—Amazing Oddities & Appalling Images
 Volume 6—Spiritual Topics

SPECIFICATIONS:
MACINTOSH® : Accessible through page layout programs including PageMaker®, ReadySetGo!™, and Quark XPress™. Minimum recommended memory requirement is 640K and a hard drive. Art comes on DS/DD disks. Also accessible with Aldus Freehand® and Adobe Illustrator® for modifications.
IBM® AND COMPATIBLES: Accessible through page layout programs including PageMaker®, Ventura Publisher®, WordPerfect® 5.0 and 5.1 as well as other programs supporting TIF. Minimum memory requirement for importing images into your page layout programs is 640K and a hard drive. Art comes on 3 1/2" DS/DD disks and 5 1/4" DS/DD floppy disks.

ACKNOWLEDGMENTS

Thanks to the hundreds of youth ministers who have submitted ideas for these illustrations. Thanks also to these artists who have contributed to the books:

Michelle Baggett
Bruce Day
Chris England
Tom Finley
Corbin Hillam
Mark "Lindy" Lindelius
Dan Pegoda

Also, thanks to our team at The Church Art Works:

Kelley Adamson
Michelle Baggett
Mike Bartlett
Bruce Bottorff
Jeff Sharpton
Beth Weld

And finally, thanks to our wives, Kelley and Kathy, for allowing us to work evenings and weekends to see this dream come to reality.

INTRODUCTION

We've designed ArtSource™ to be a quick and complete sourcebook for your youth program promotions. It contains art from The Church Art Works' extensive files of ministry clip art, as well as from several other contributing artists. The art is arranged by subject and will cover most activities you'll be involved in during the year. Future volumes will supply new subjects as well as additional art for the current subjects.

We want this book and others in the series to be a real asset to your ministry. You can help us with ideas for more clip art by using the Brainstorm Form on page 14. When you submit your ideas to us, you keep the creativity flowing. We hope our efforts will assist all of you in your ministries as you work for positive growth in your students.

LET'S BE CREATIVE!

This book gives you the chance to be creative, pumping life into your promotions and creating excitement in your group. Just follow these four easy steps:

1. *CREATE AN EXCITING IDEA.* Planning and scheduling your youth group activities in advance is essential. But don't stop there. Hold separate brainstorm sessions to allow time for creativity to blossom. Creative ideas don't come easily in a "board meeting" format, so get away to a wacky place or neutral territory with a few "crazy" idea people. The clip art contained in this book should inspire some ideas you may not have considered. Once the ideas are on paper, sort them out and plan the logistics later. This will help you break away from the pressures of your everyday work and will keep your ideas fresh.

2. *CREATE AN EXCITING MESSAGE.* When you prepare your information, think like a kid. Don't be trapped into just listing the "time, date, and place." To expand your thinking, we've shown you four examples of possible layouts on pages 12 and 13.

BASIC STEPS IN PREPARING PRINTED MATERIALS

Helpful tools that will make your job easier are a pair of scissors, an x-acto (craft) knife, a ruler, a light blue pencil (nonreproducing) for layout, rubber cement, glue stick or wax for adhesive, tape, black felt-tip pens of various widths, a t-square, triangles, sheets of transfer lettering (rub-on type), a technical pen, and a drafting table or drawing board. All of these tools are available from your local art/ drafting store.

Photocopy or cut out pieces of art from this book for your project. You can reduce it or enlarge it on a photocopier. Choose art that fits your subject.

Plan your layout. Sketch (on a separate piece of paper) where you want art and where you want copy (headlines and details). See pages 10-13 for ideas.

Use felt-tip pens, a typewriter, or a desktop computer to set your type. Assemble this in combination with the clip art and paste it on a clean white sheet or card for your "master."

Copy the master to reproduce as many printed pieces as you need for your event. Copying can be done on your photocopier or at a print shop.

3. *CREATE AN EXCITING LOOK.* Think beyond the "normal" approach in laying out information for an announcement or flyer. Young people love seeing the unusual. Instead of aligning things straight, place them at an angle on the page. If you're comfortable with small type, think BIG type. And if you're tempted to illustrate your message with a normal-looking teenager (whatever that is), use a fat hippo instead!

As you begin your layout of a flyer or poster, grab a nice big piece of paper, a pencil, and a few pieces of clip art . One way to be sure you don't get trapped into the same old layout procedure is to lay the clip art on your layout sheet first. Let it be as big as you want, just so that it's fun and has impact. Enlarge it if necessary, <u>then</u> work the rest of the copy and headlines around the art. This will create some unusual shapes and column widths. It'll be easier and more fun!

You can also use the paper and pencil to roughly sketch out small (2"-3") layout options. Explore radically different layouts of the various elements in your piece. For example, in one sketch the art may be huge with small supporting type; in another, the type may be huge with the art sized fairly small. You have many different options with the same piece of clip art — such as repeating it several times for a border effect.

4. *CREATE AN EXCITING ATTITUDE.* After you've committed your plans to God, promoting your event is the first step toward contacting those you want to reach. Stretch yourself and strive for the very best. This new attitude will be reflected in your work. Others will sense your desire for creativity and professionalism, and the enthusiasm will spread. As more people become involved in the project, you'll also stretch them. The results will be exciting, as the "team" begins to focus on a worthwhile goal.

In the following pages we've put words into action by giving you creative samples of ways to use clip art. Use these ideas to launch your own exciting promotional pieces. Have fun!

SUPER WAYS TO PROMOTE YOUR ACTIVITIES

Add interest to your events by hyping them often and in as many ways as possible! The more you promote, the more your students will see the importance of the event.

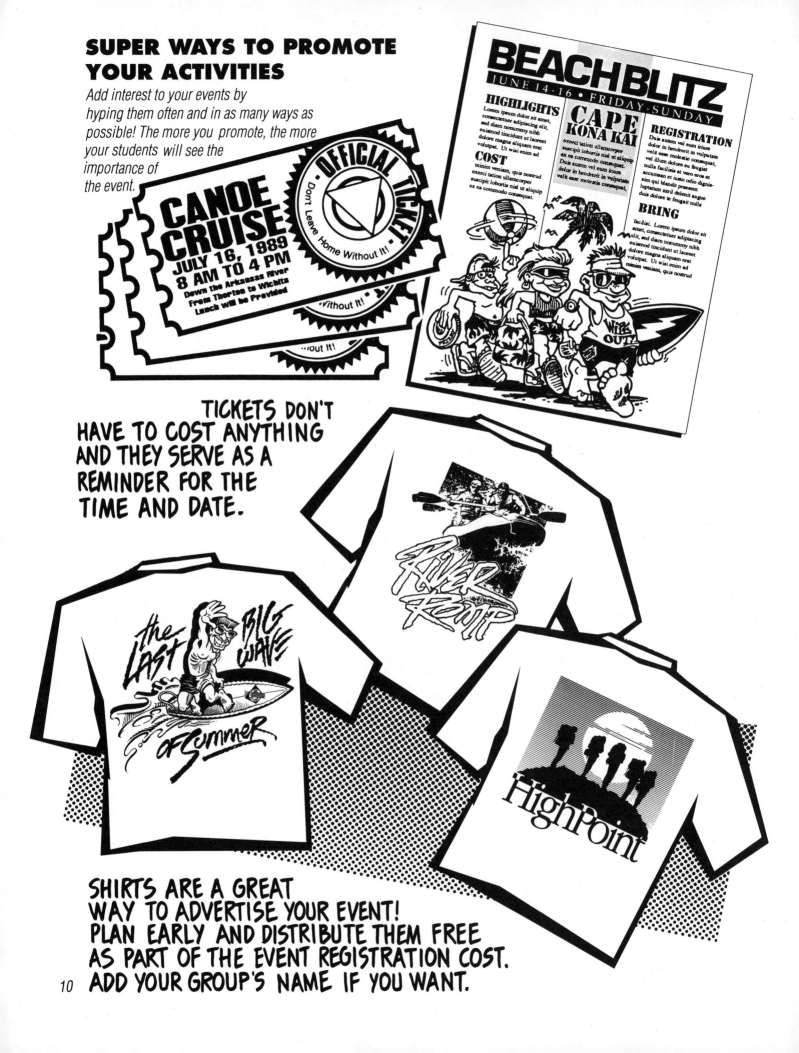

TICKETS DON'T HAVE TO COST ANYTHING AND THEY SERVE AS A REMINDER FOR THE TIME AND DATE.

SHIRTS ARE A GREAT WAY TO ADVERTISE YOUR EVENT! PLAN EARLY AND DISTRIBUTE THEM FREE AS PART OF THE EVENT REGISTRATION COST. ADD YOUR GROUP'S NAME IF YOU WANT.

SOMETIMES CLIP ART
IS ONLY A MINOR PORTION
OF THE TOTAL LAYOUT. THE
DARK BARS OF INK AND THE
DROP SHADOW BOXES HELP TO
ADD VARIETY TO THE FLYER.
MANY TYPE TREATMENTS THAT
INVOLVE "REVERSE" TYPE OR SHADOW
LETTERING CAN BE DONE
ON A COMPUTER.

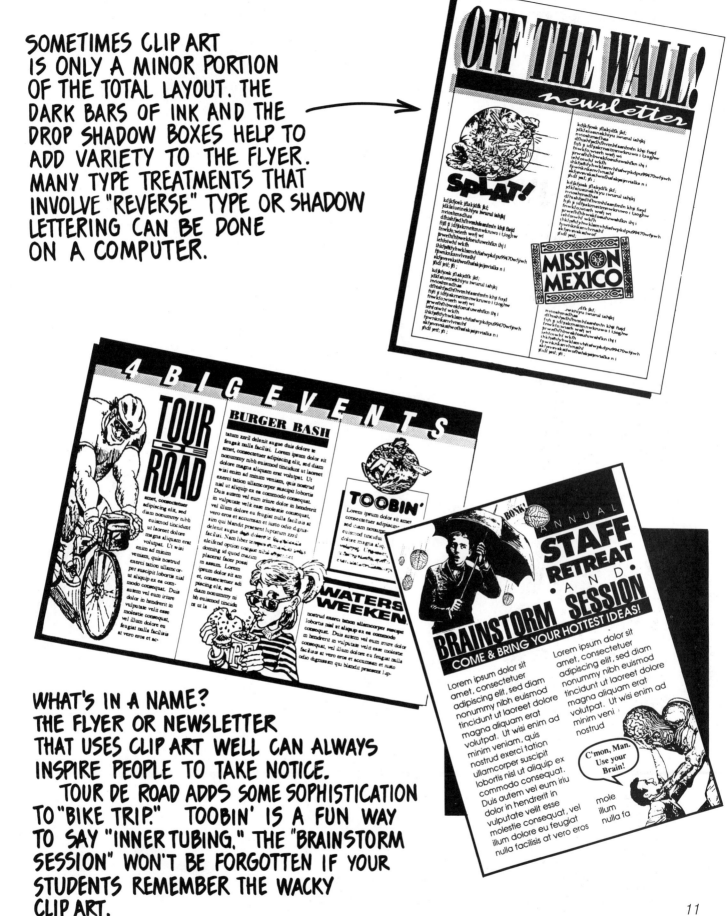

WHAT'S IN A NAME?
THE FLYER OR NEWSLETTER
THAT USES CLIP ART WELL CAN ALWAYS
INSPIRE PEOPLE TO TAKE NOTICE.
 TOUR DE ROAD ADDS SOME SOPHISTICATION
TO "BIKE TRIP." TOOBIN' IS A FUN WAY
TO SAY "INNER TUBING." THE "BRAINSTORM
SESSION" WON'T BE FORGOTTEN IF YOUR
STUDENTS REMEMBER THE WACKY
CLIP ART.

THINGS TO CONSIDER WHEN PLANNING A LAYOUT.

We've selected the "atomic boogie" art from page 79 and have used it in four different layouts to show you the variety you can achieve in creating a flyer. We've made notes to call your attention to the key points.

REPEATING OR "FLOPPING" THE ART CAN CREATE A MORE INTERESTING APPROACH. WE'VE ELIMINATED THE TYPE ON ONE ILLUSTRATION BECAUSE IT WOULD BE BACKWARD WHEN FLOPPED.

CREATE A UNIQUE MESSAGE TO GO ALONG WITH THE ART. A LITTLE JAMAICAN DIALECT, OR AN OBVIOUS MISSPELLING WILL HELP YOUR MESSAGE STICK.

OVERLAPPING THE ELEMENTS IN A LAYOUT SMOOTHS THE FLOW BETWEEN THEM. NOTICE HOW THE CARTOON AND THE HEADLINE GIVE A "ONE-TWO" PUNCH TO START THINGS OFF.
 THE BLACK BAR USED BEHIND THE HEADLINE GIVES MORE LENGTH TO TUCK BEHIND ILLUSTRATION.

REMAINING FACTS CAN BE COVERED IN BRIEF, BUT CAN CONVEY A LOT OF INFO IN A SMALL AMOUNT OF SPACE.

ATOMIC BOOGIE
MEN ONLY!
OTTER ROCK BEACH · SAT. APRIL 14
$5.

EQUIP: Wetsuits may be rented from Andersons for $12 or from Oregon Surf Shop in Taft for $10
Boards may be borrowed from friends for free or rented from Oregon Surf Shop for $5

INFO: Transportation & Food will be provided.
Experienced Hawaiian Bonzai Boarders Dave Adamson & Gary Walter will be your guides.

U GOTTA BOOGIE WITSHU BRUDDA, MAHN

ATOMIC BOOGIE
(MEN ONLY)
SAT. APRIL 14
at Otter Rock Beach
$5

EQUIPMUNT
Wetsuits may be rented from Andersons for $12 or from Oregon Surf Shop in Taft for $10.
Boards may be borrowed from friends for free or rented from Oregon Surf Shop for $5.

INFOMASHUN
Transportation & Food will be provided
Experienced Hawaiian Bonzai Boarders Dave Adamson & Gary Walter will be your guides

U GOTTA BOOGIE WITSHU BRUDDA, MAHN"

TALL VERTICAL LAYOUT OF THE ART LEFT A TALL, THIN COLUMN FOR THE TYPE. THIS CREATES A SMOOTH FLOW DOWN THE PAGE AND AVOIDS THE BOXY LOOK OF WIDE COLUMNS WITH A SMALL CLIP ART PIECE AT THE END OF THE COLUMN.

DARK BAR ON THE LEFT SIDE ADDS STRENGTH TO THE "MEN ONLY" TYPE. IT ALSO ADDS VARIETY TO THE TYPE IN THE OVERALL LAYOUT.

THE HEADLINE AND THE ART MATCH WELL. NO MATTER HOW LARGE THE TYPE, IF IT ISN'T COMPATIBLE WITH THE ILLUSTRATION, IT WON'T HAVE THE SAME IMPACT.

LARGE ILLUSTRATION "CARRIES" THE ENERGY IN THIS LAYOUT. THE TYPE IS BROKEN UP INTO "BITESIZE" BITS OF INFO BY ALTERNATING BOLD TYPE, ALL CAPS, OR "UPPER AND LOWER" TYPE AS WELL AS HAND LETTERING.

We want to serve you! Send us your ideas so that we can draw them for future books to assist you in your ministry.

Name_____

Church or Ministry_____

Address_____

City_____

State_____Zip_____

Phone_____

BONK!

B R A I N S T O R M F O R M

Here are some ideas I'd like to see in future books:

Food Fun:

Fundraisers:

Group Stuff:

Music:

Summer:

Winter:

Copy and send to: The Church Art Works • 875 High Street NE • Salem, Oregon 97301 • (503) 370-9377 • FAX (503) 362-5231

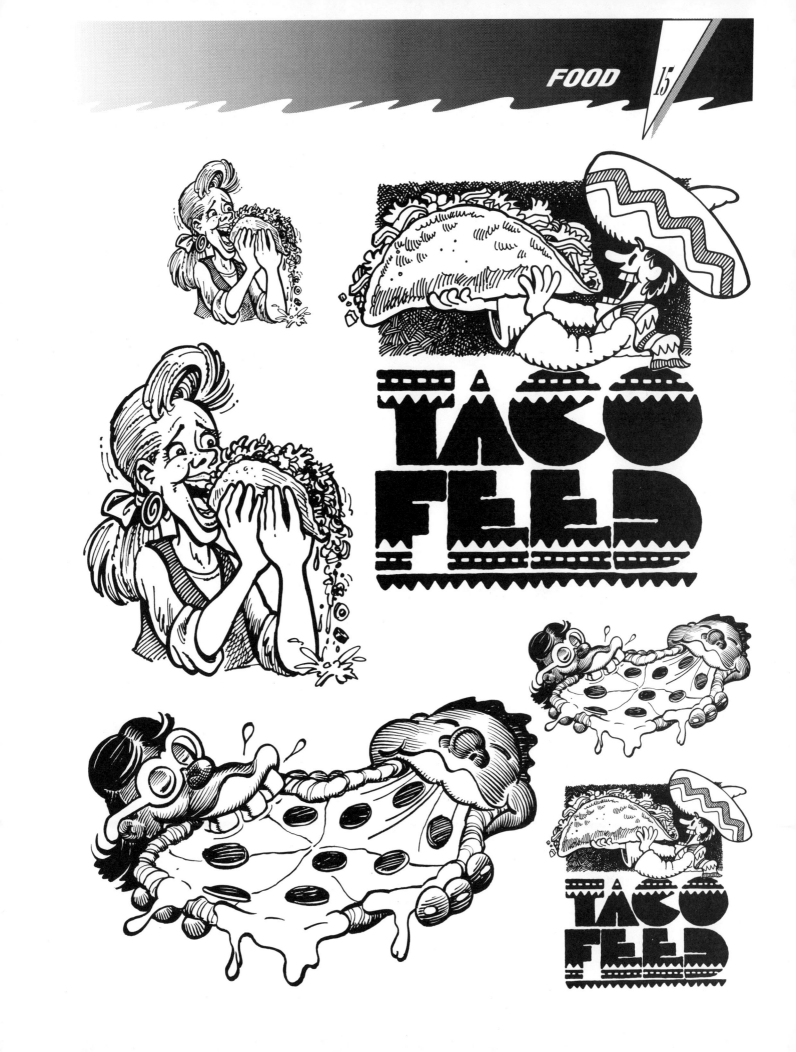

A TACO FEED

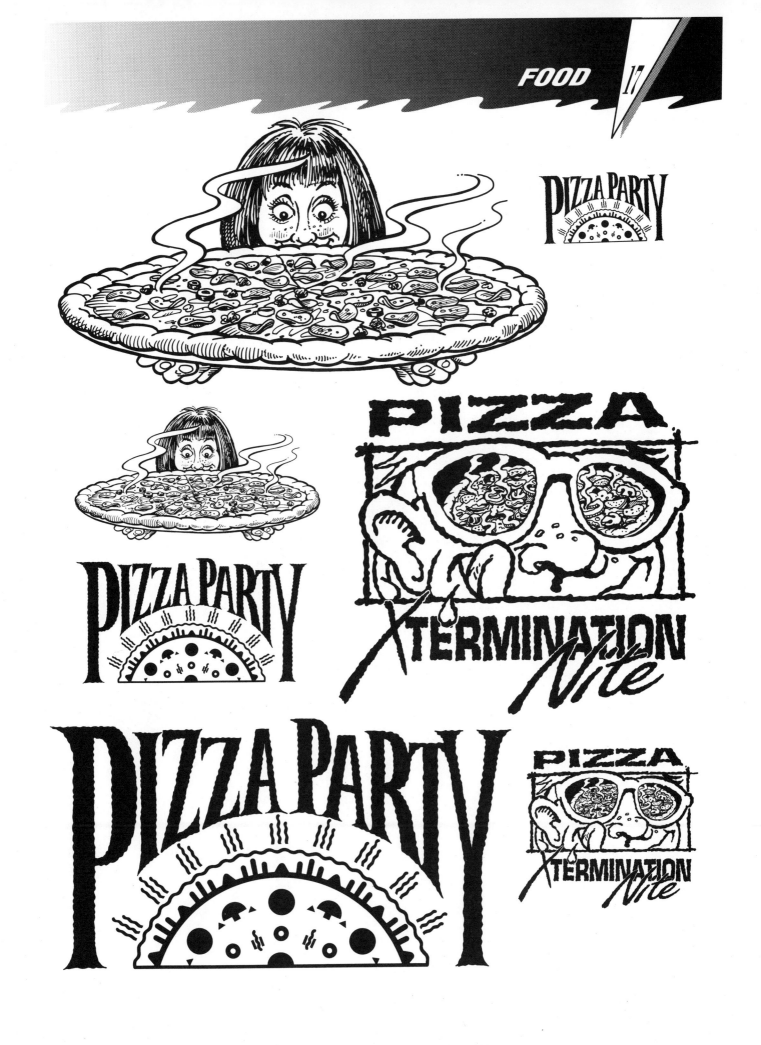

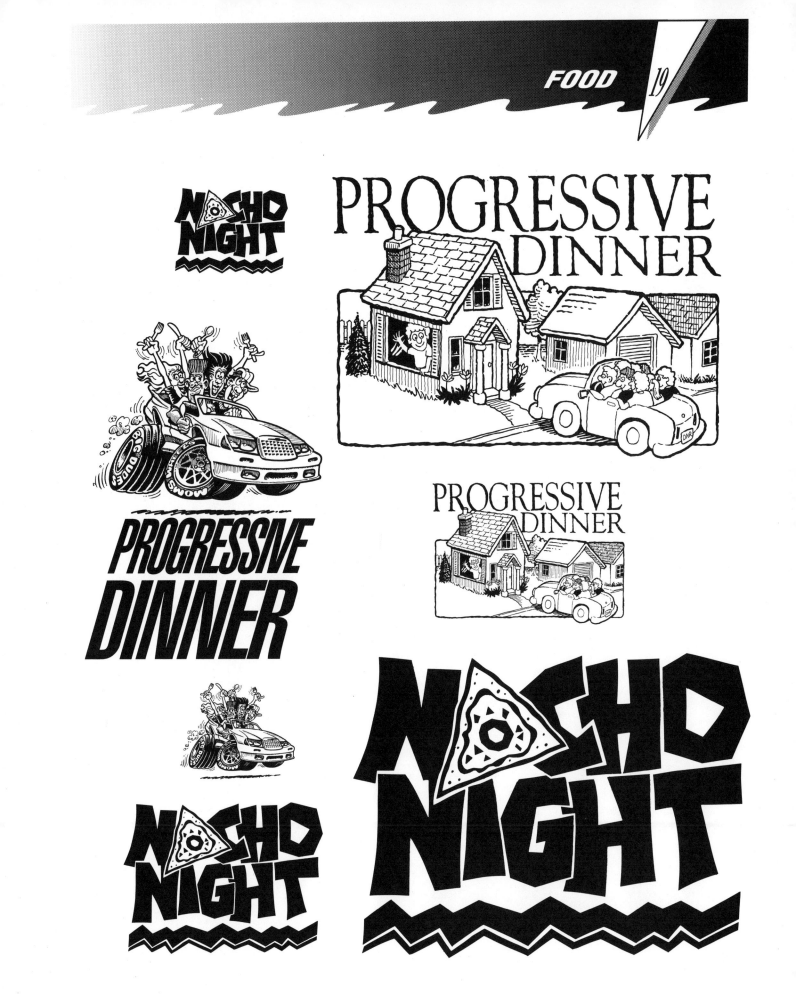

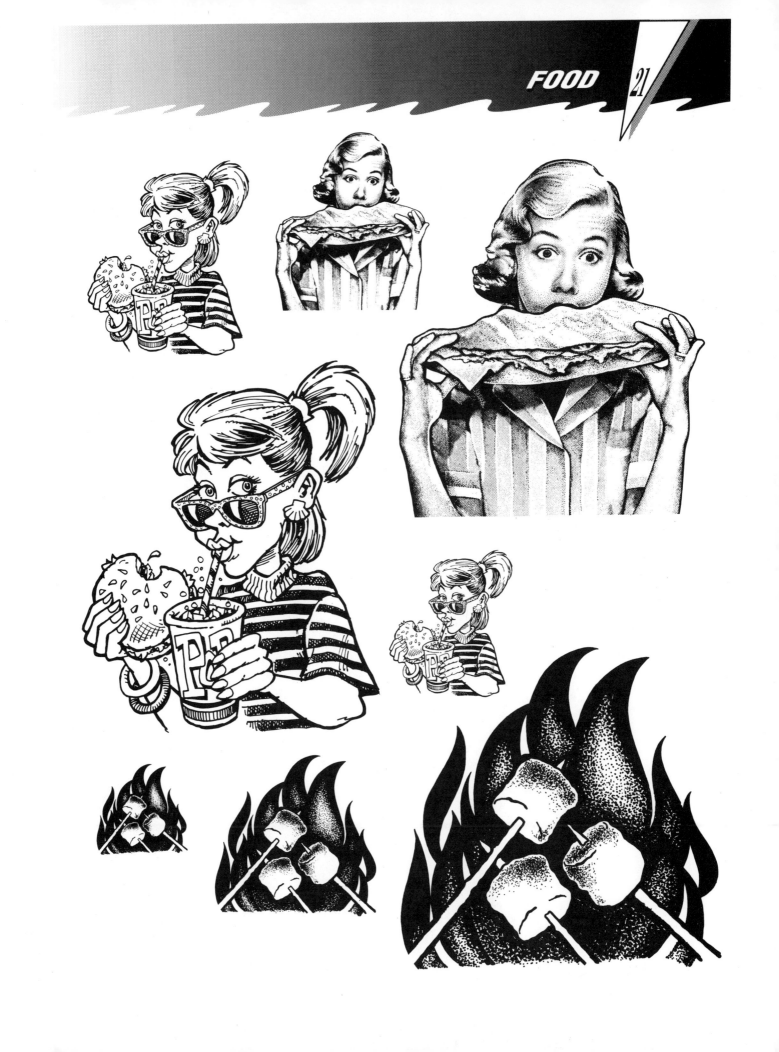

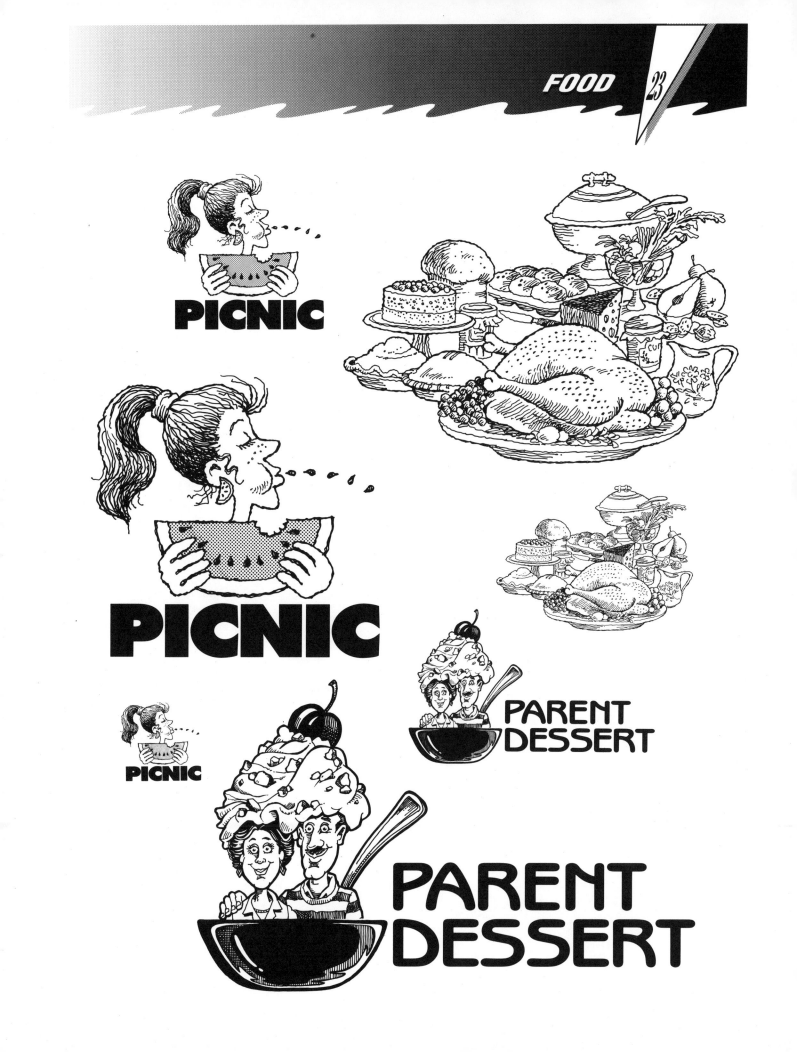

PICNIC

PICNIC

PICNIC

PARENT DESSERT

PARENT DESSERT

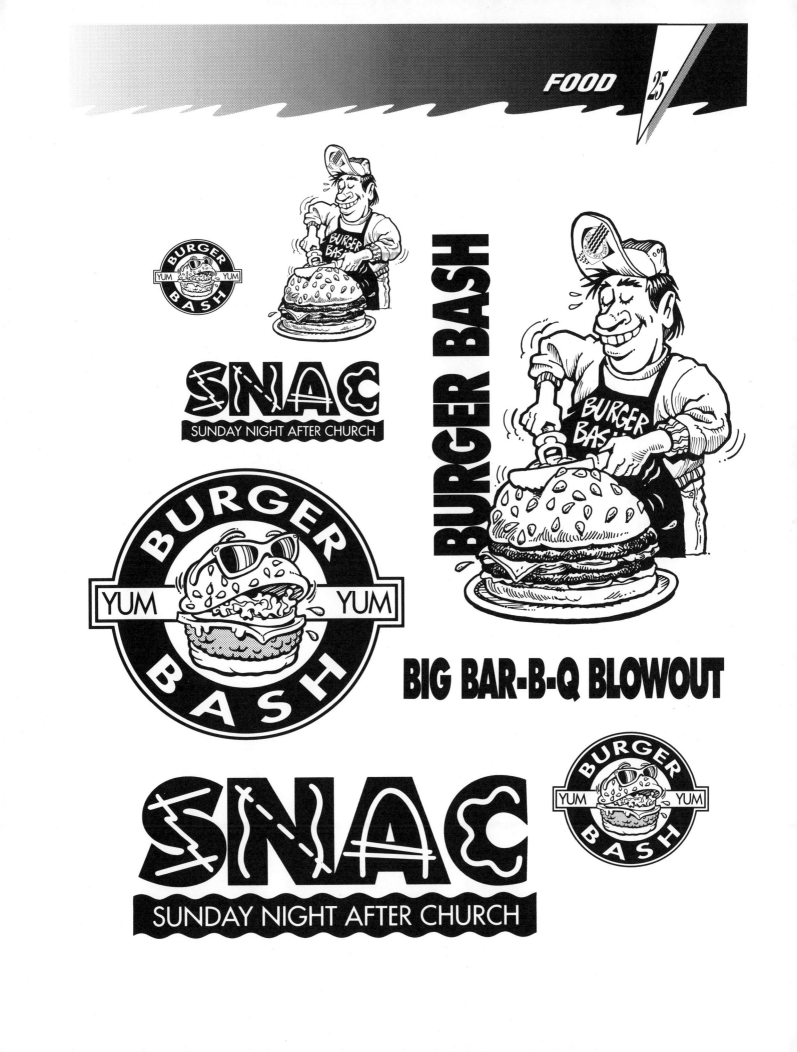

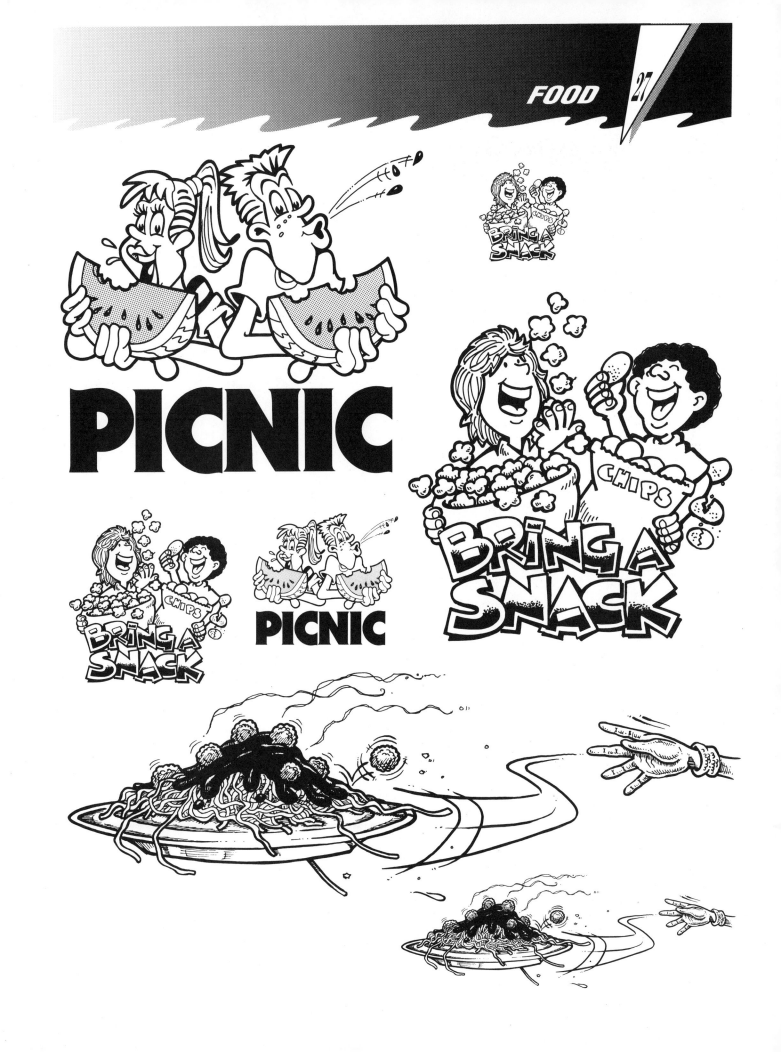

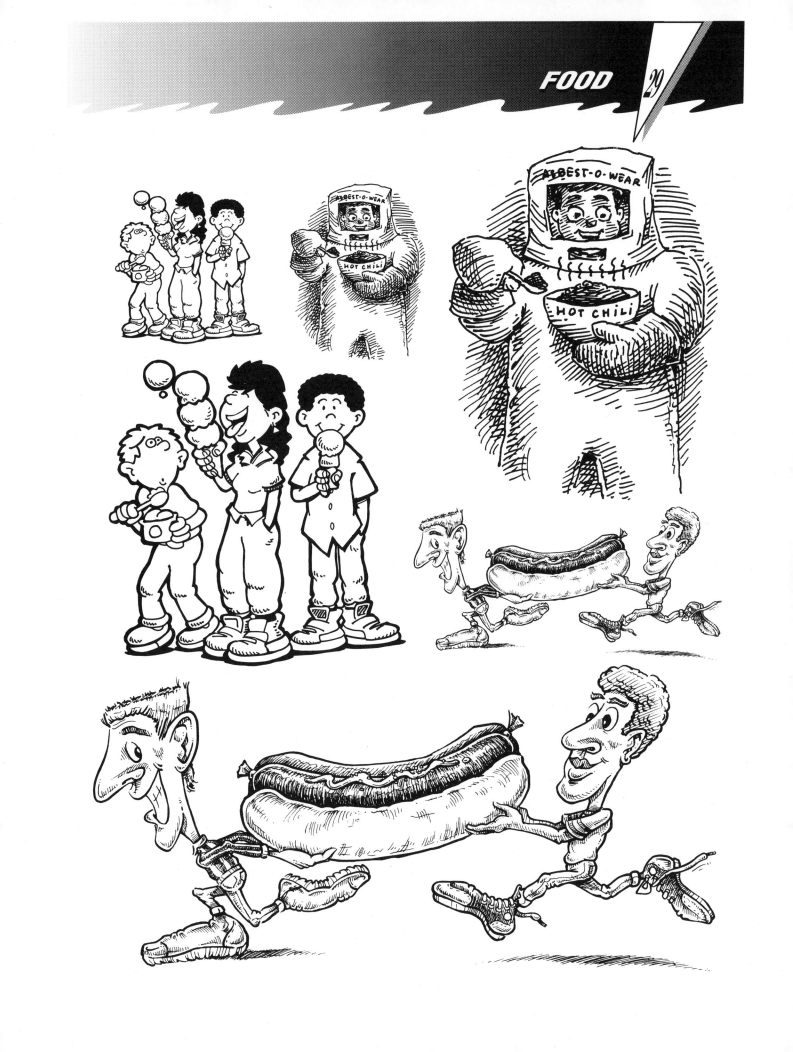

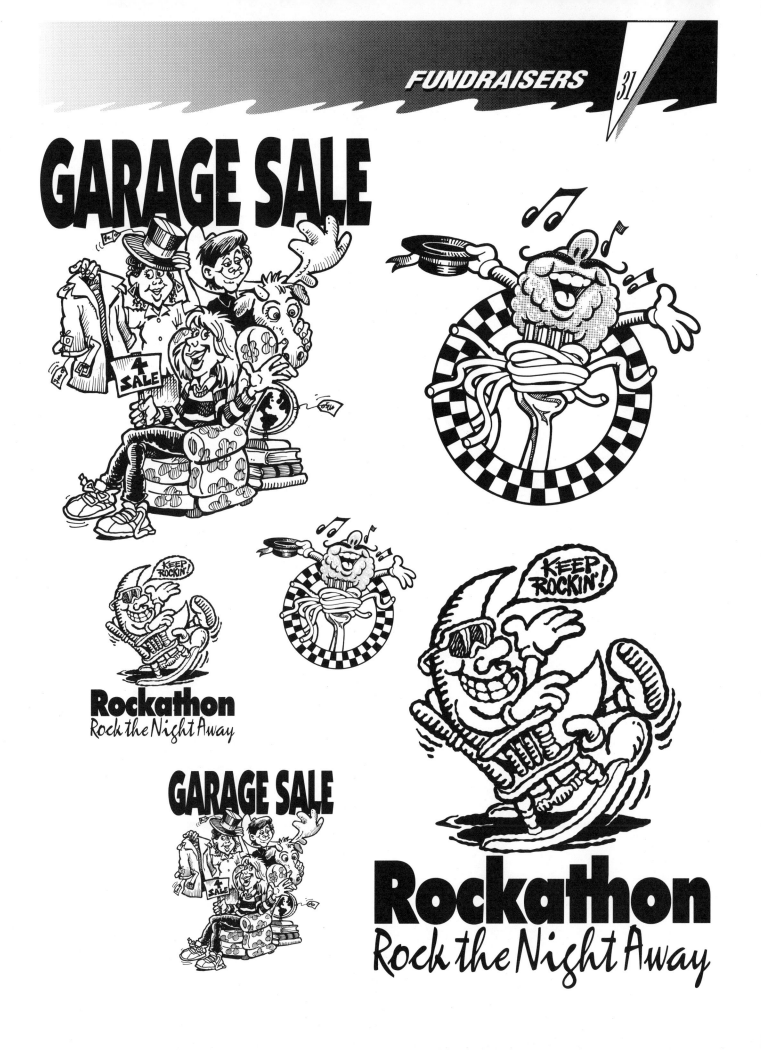

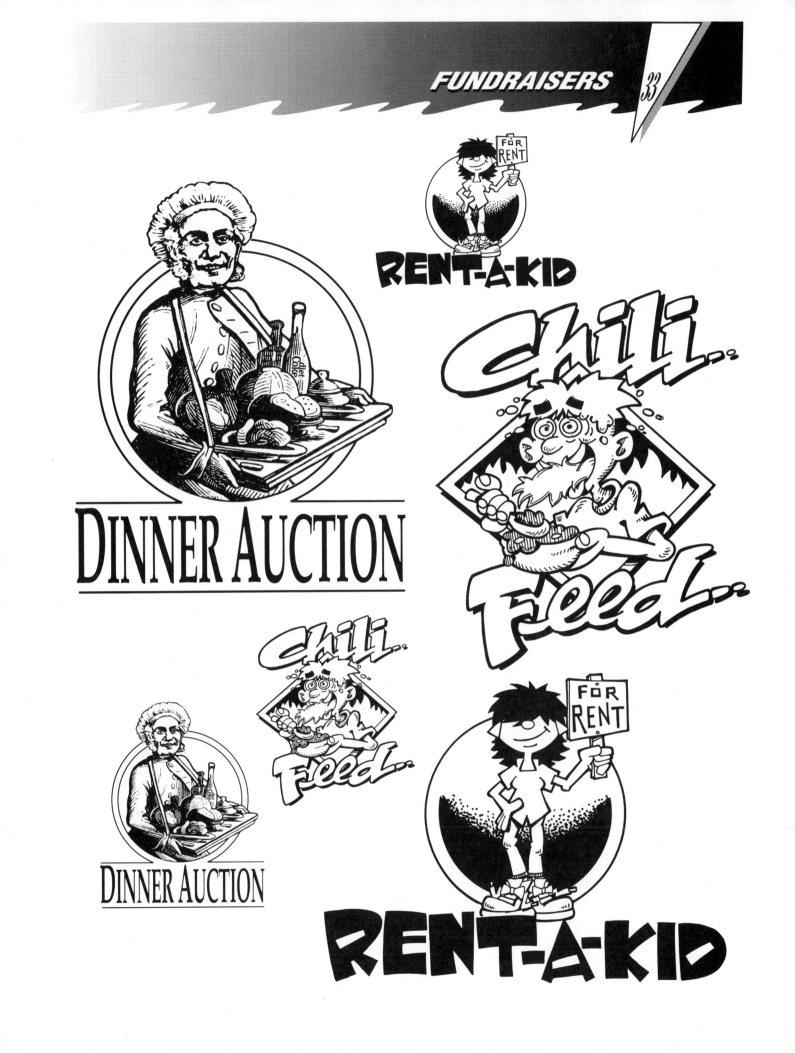

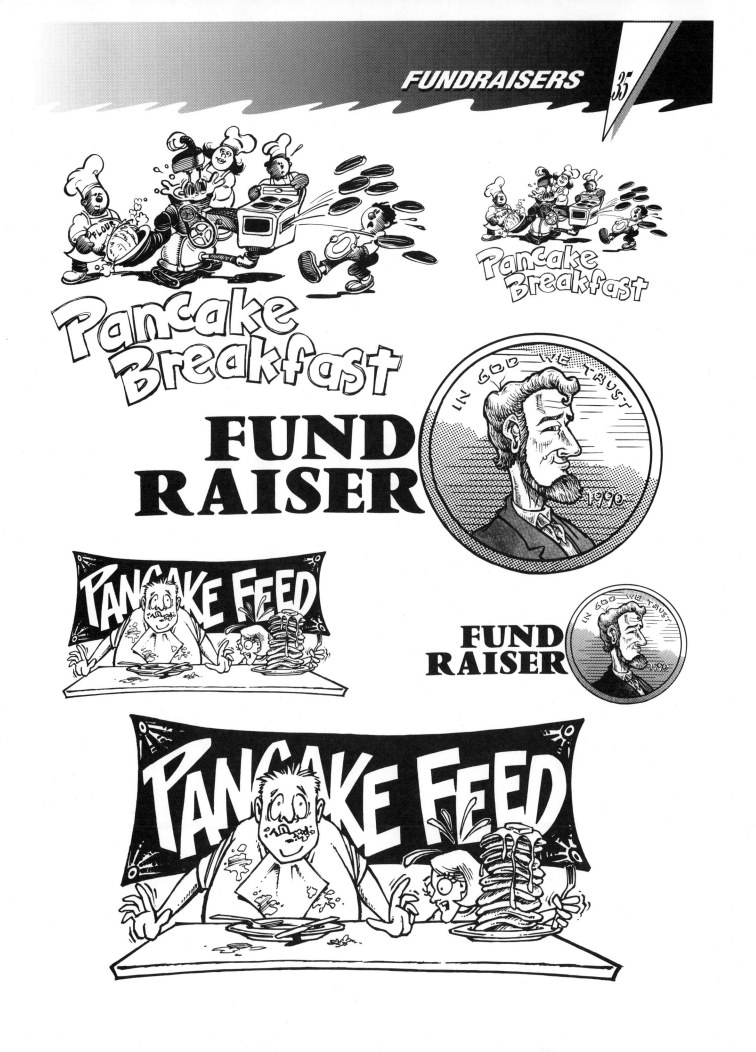

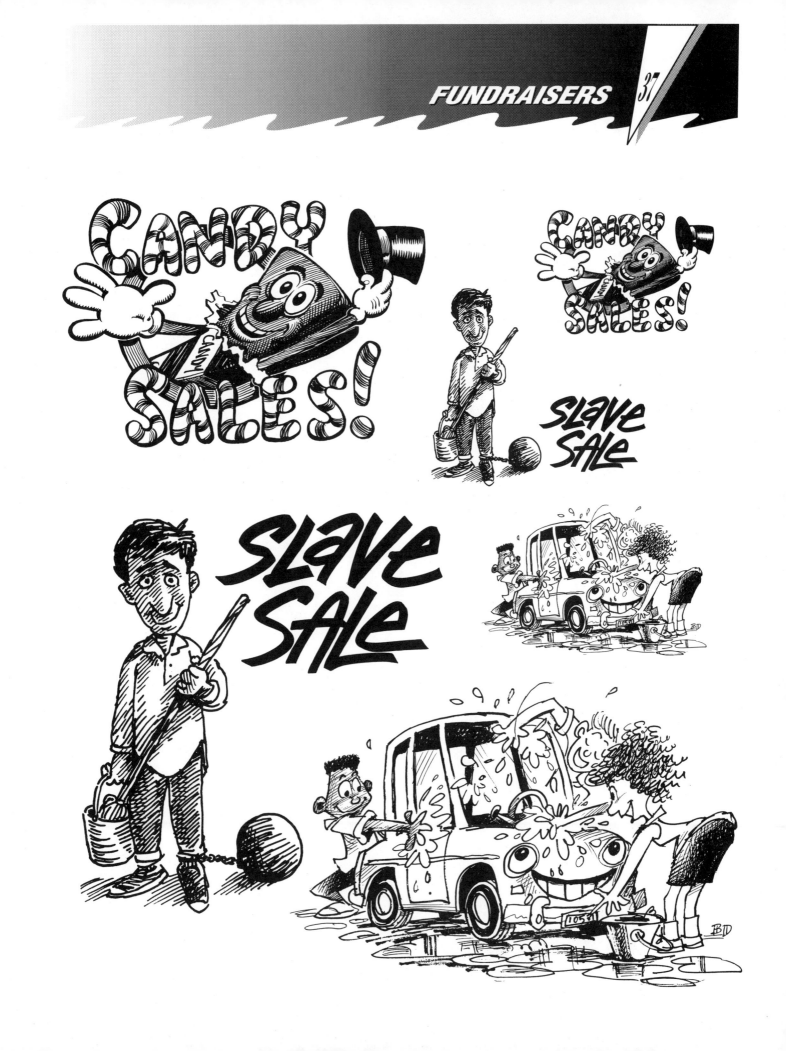

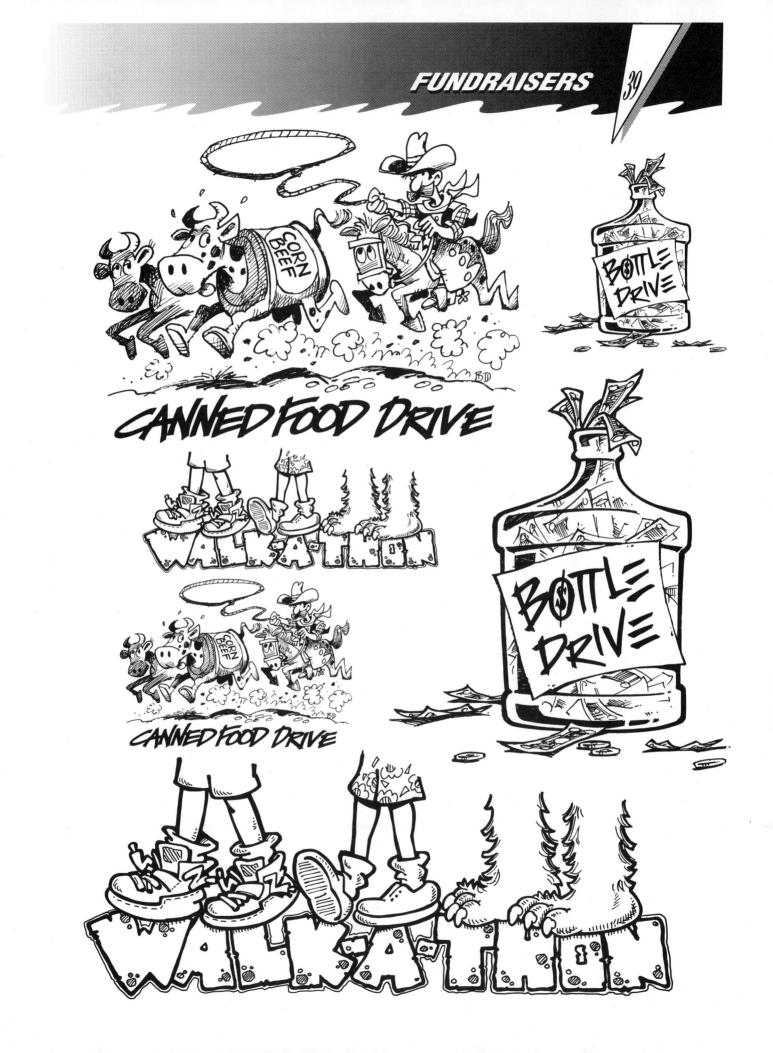

CANNED FOOD DRIVE

WALKATHON

BOTTLE DRIVE

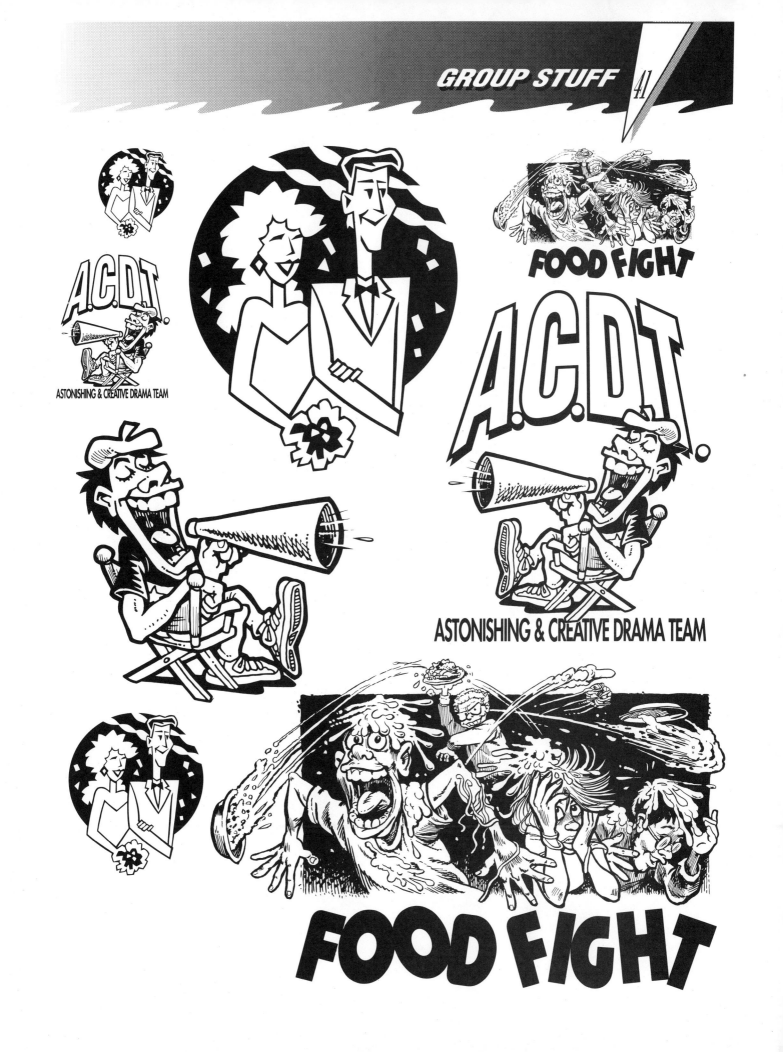

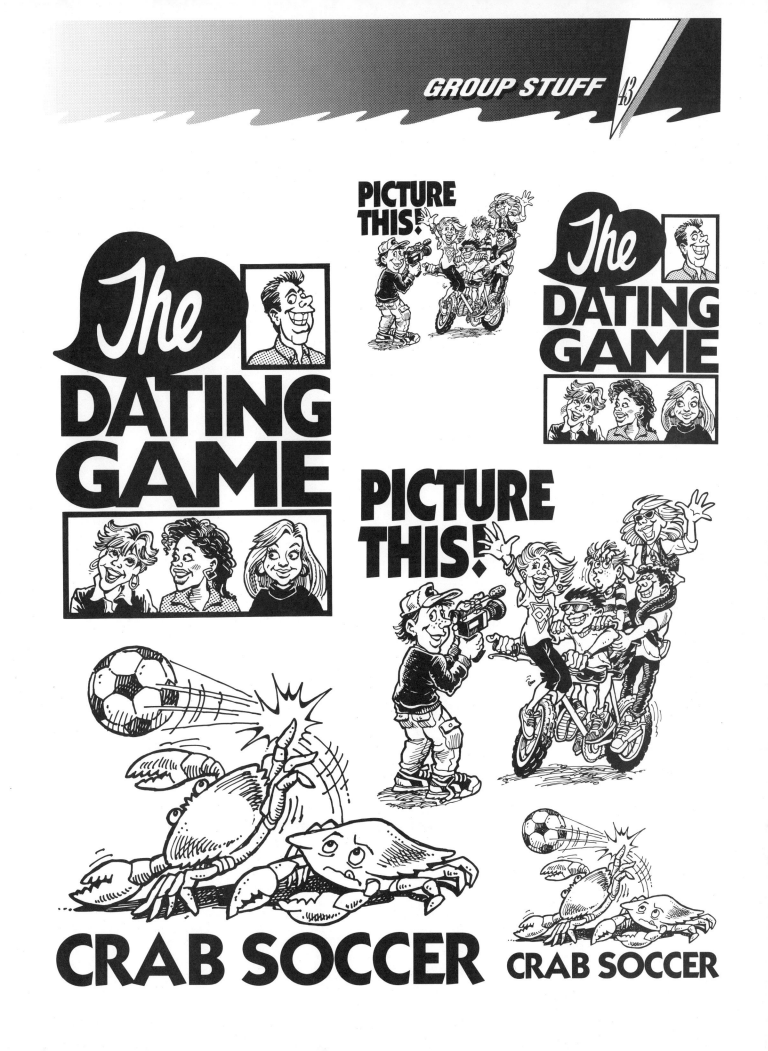

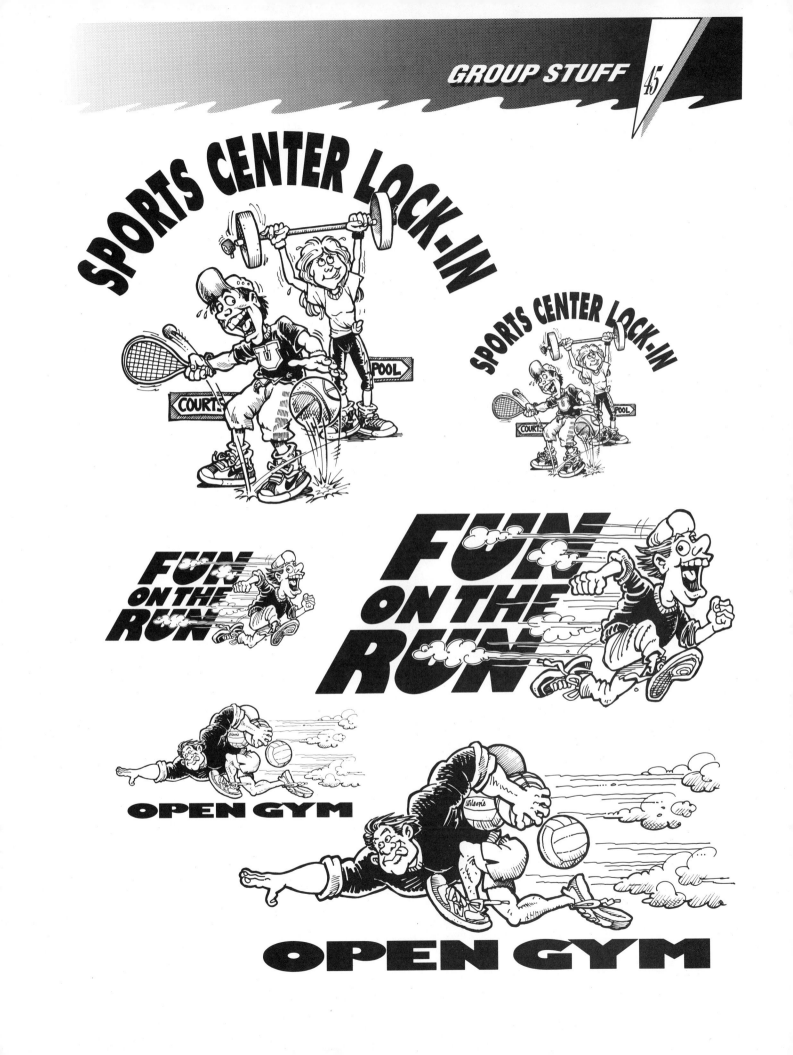

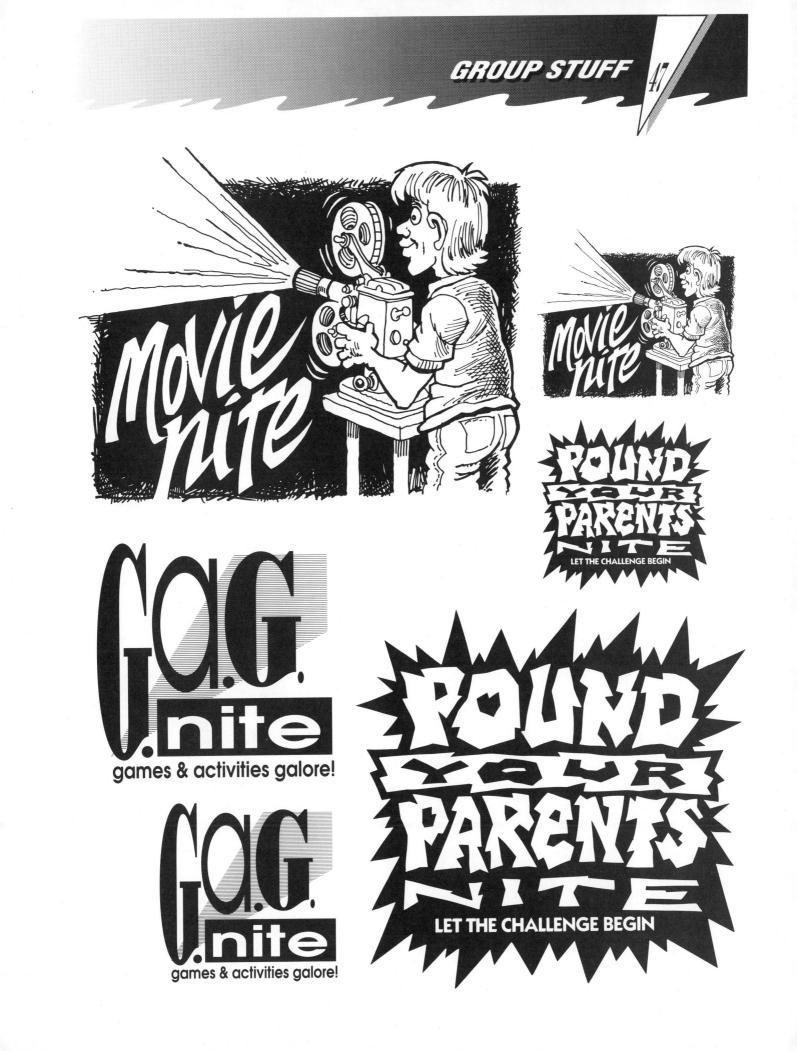

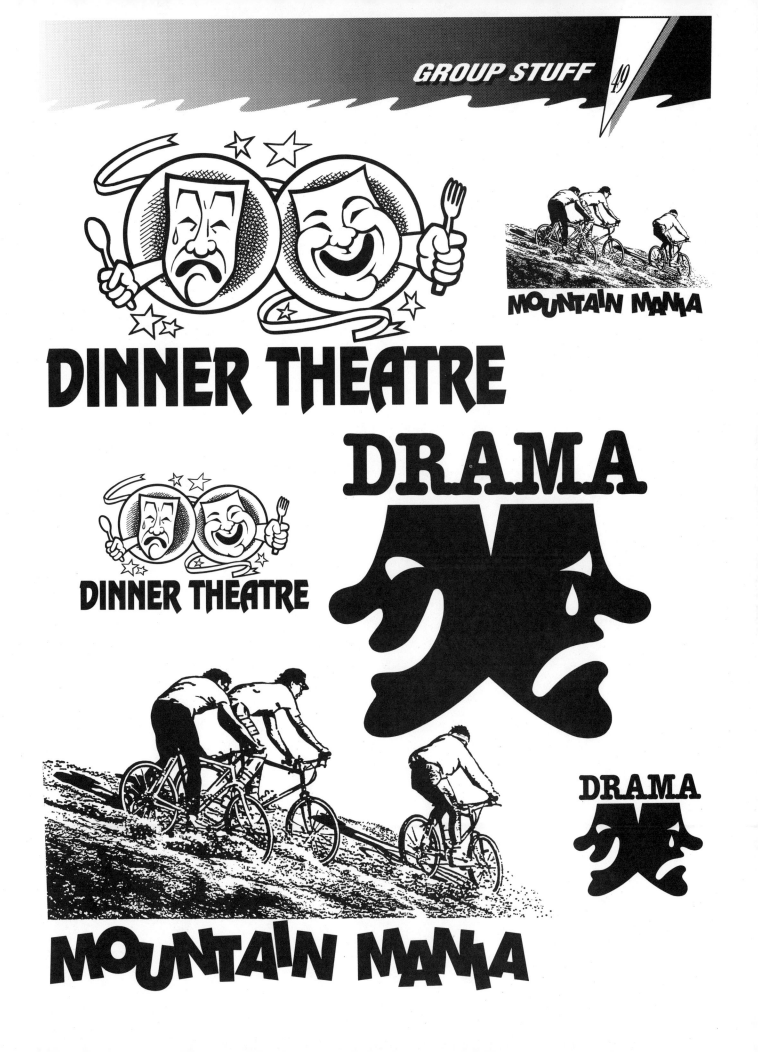

DINNER THEATRE

DRAMA

MOUNTAIN MANIA

DINNER THEATRE

DRAMA

MOUNTAIN MANIA

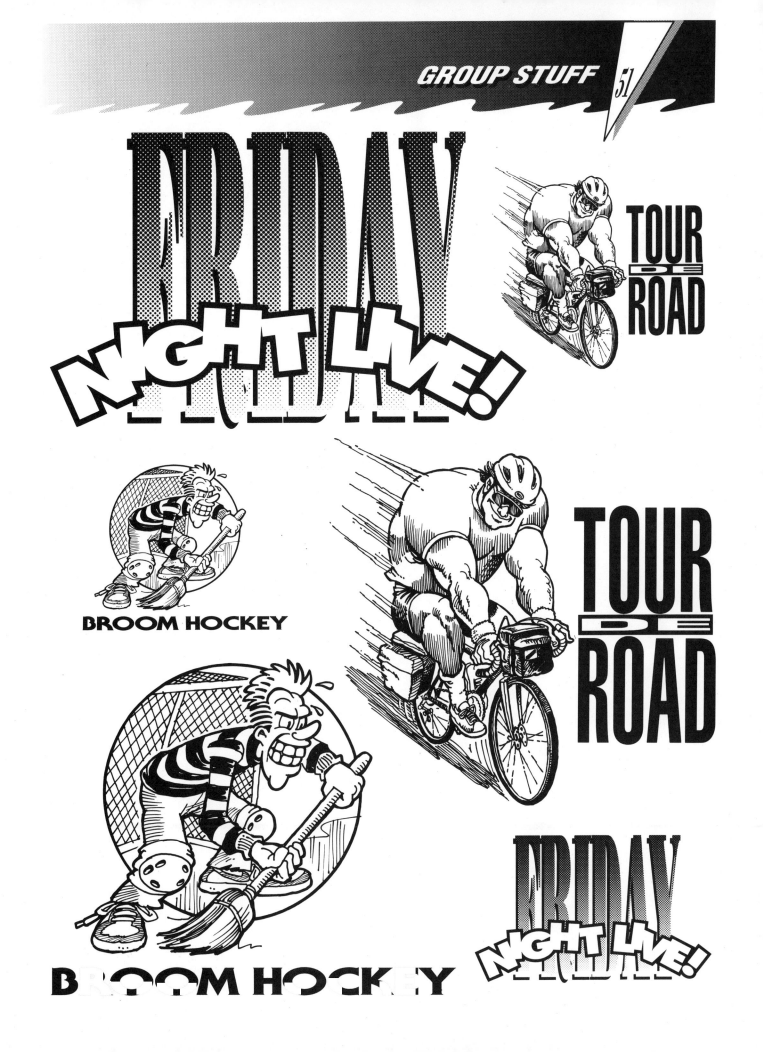

FRIDAY NIGHT LIVE!

TOUR DE ROAD

BROOM HOCKEY

TOUR DE ROAD

BROOM HOCKEY

FRIDAY NIGHT LIVE!

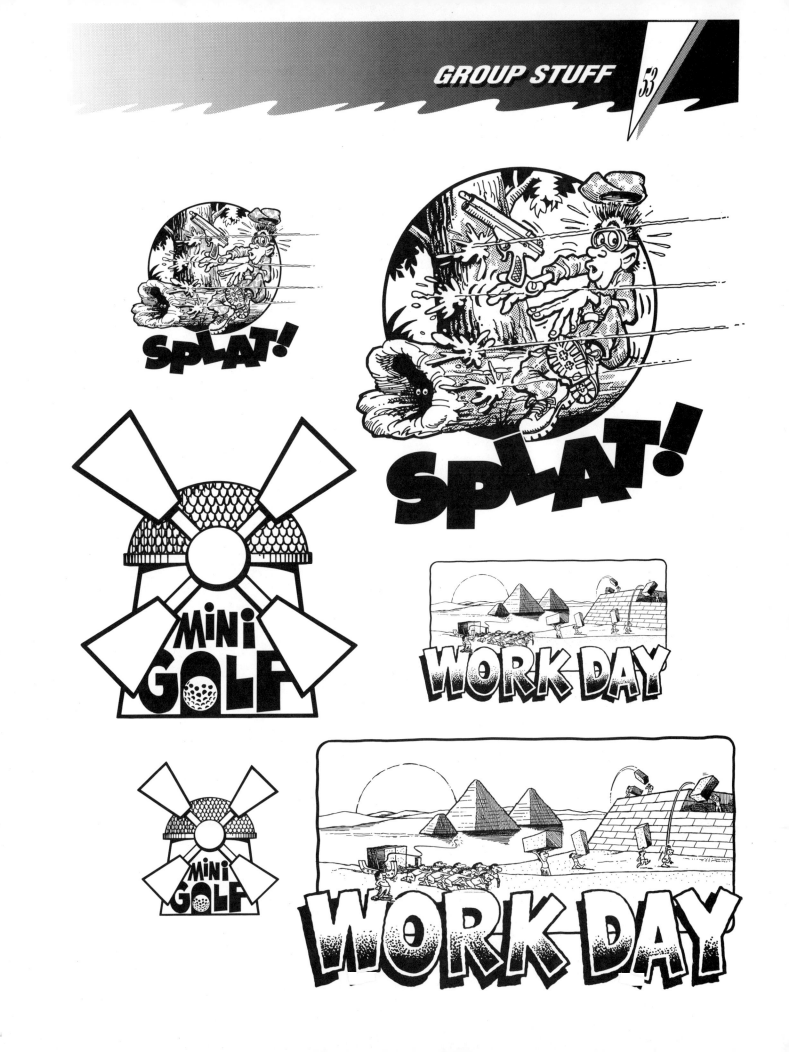

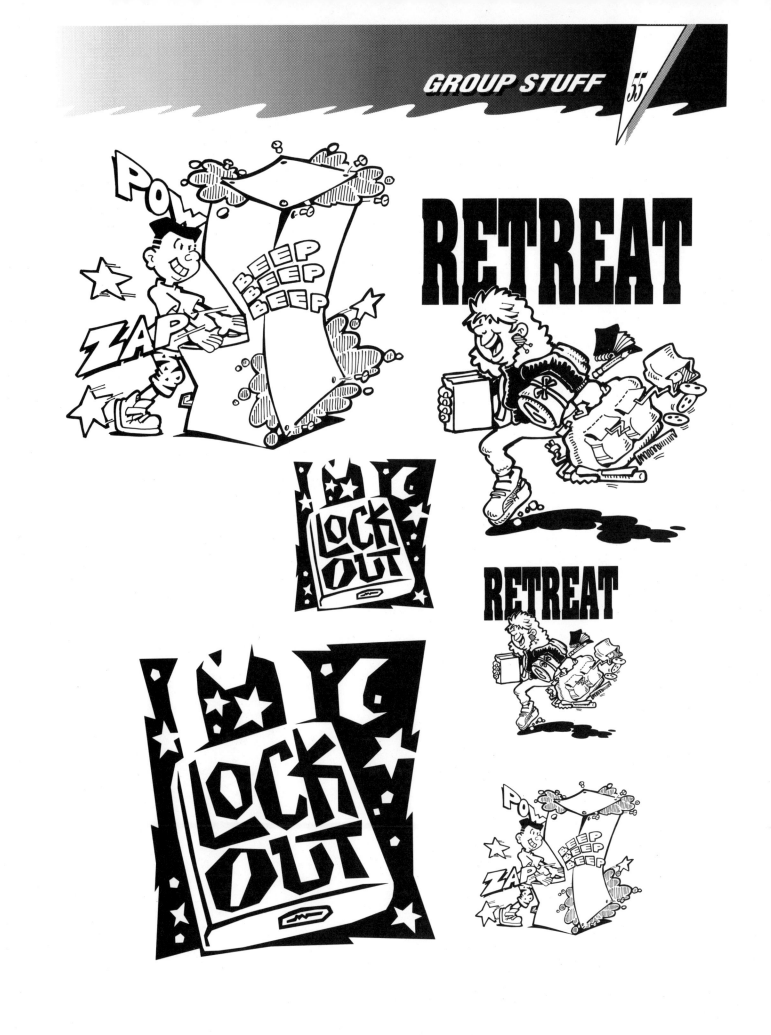

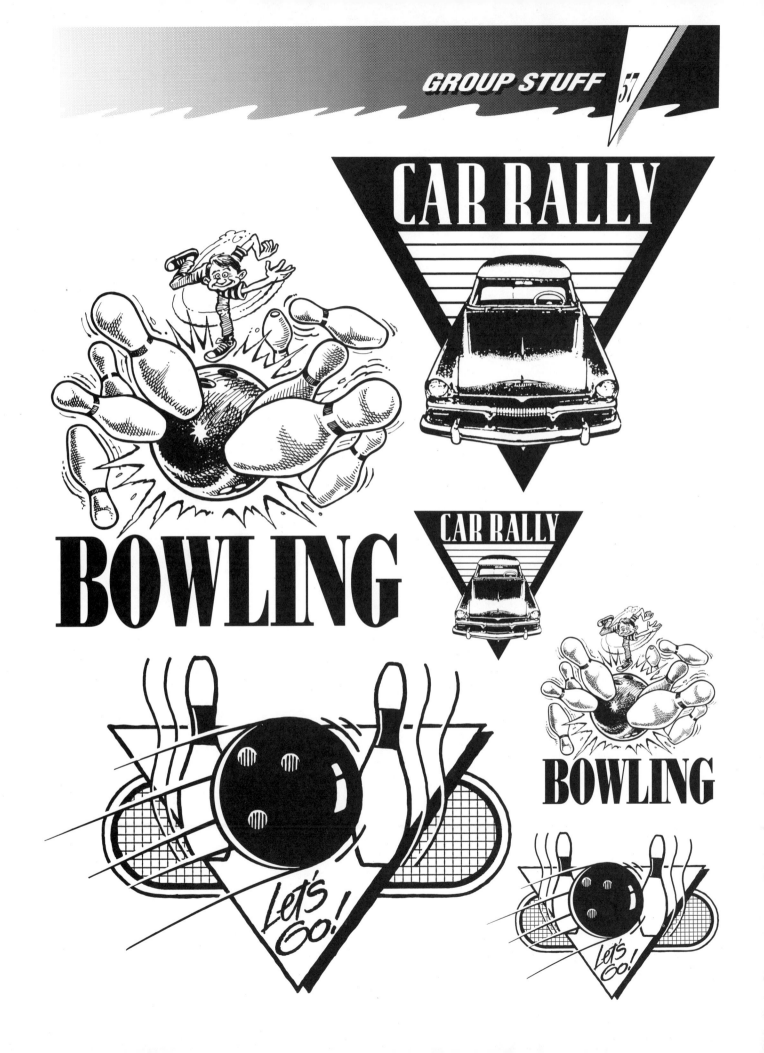

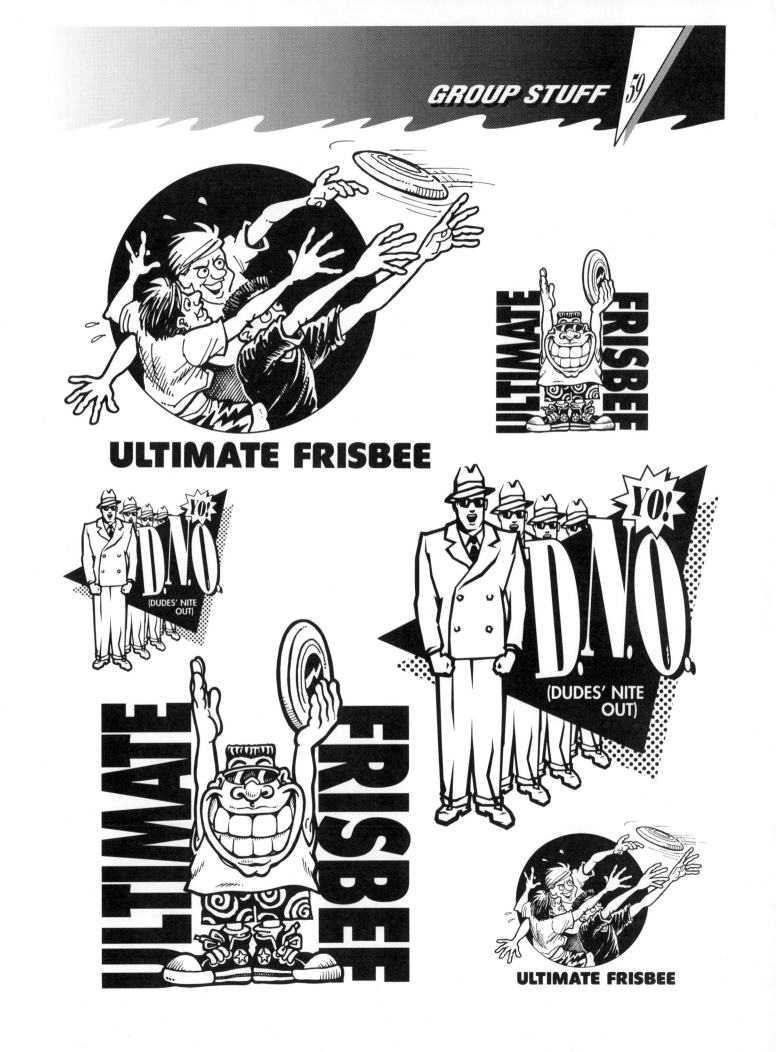

ULTIMATE FRISBEE

D.N.O.
(DUDES' NITE OUT)
YO!

D.N.O.
(DUDES' NITE OUT)
YO!

ULTIMATE FRISBEE

ULTIMATE FRISBEE

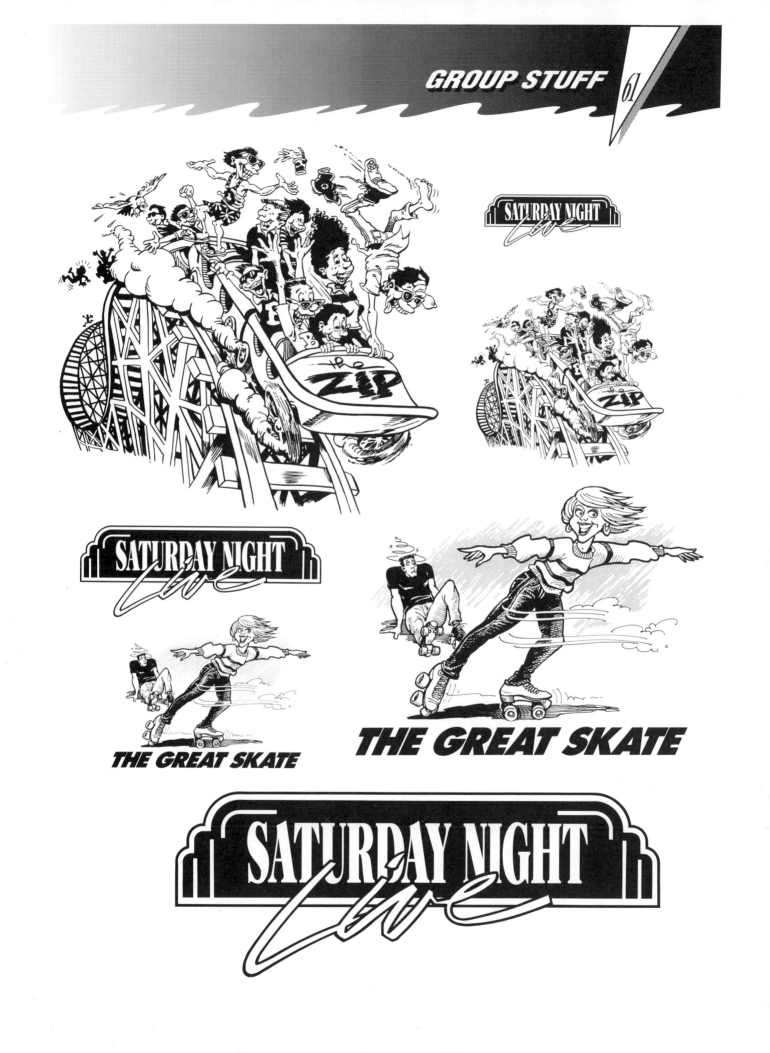

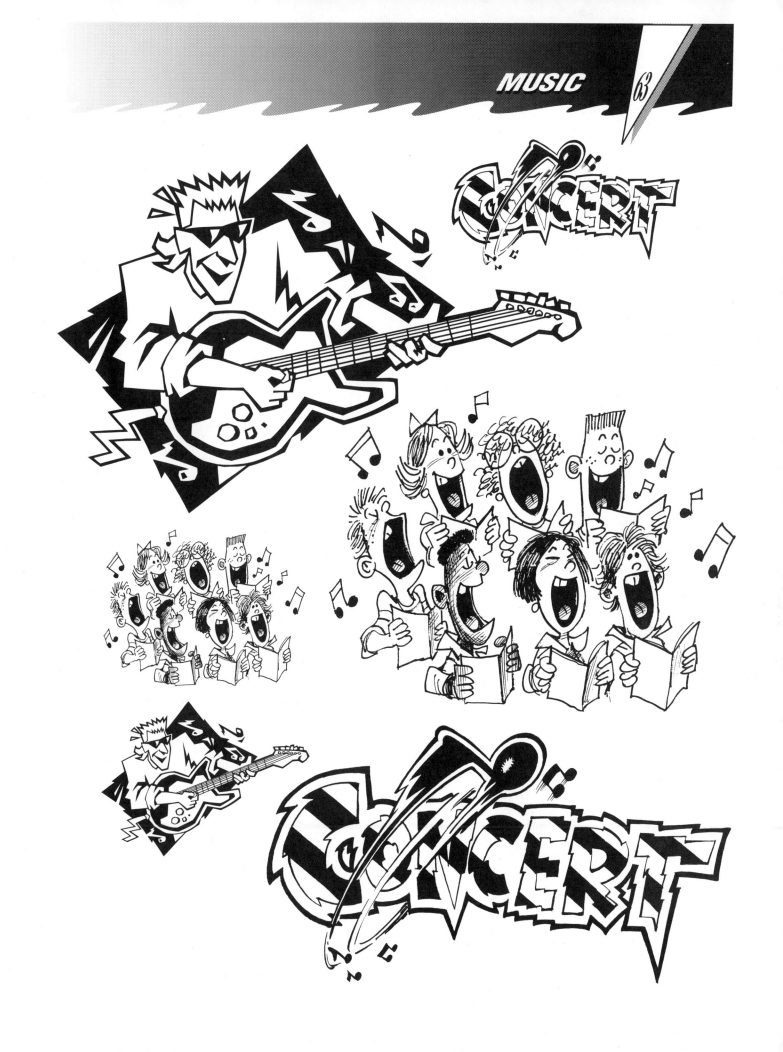

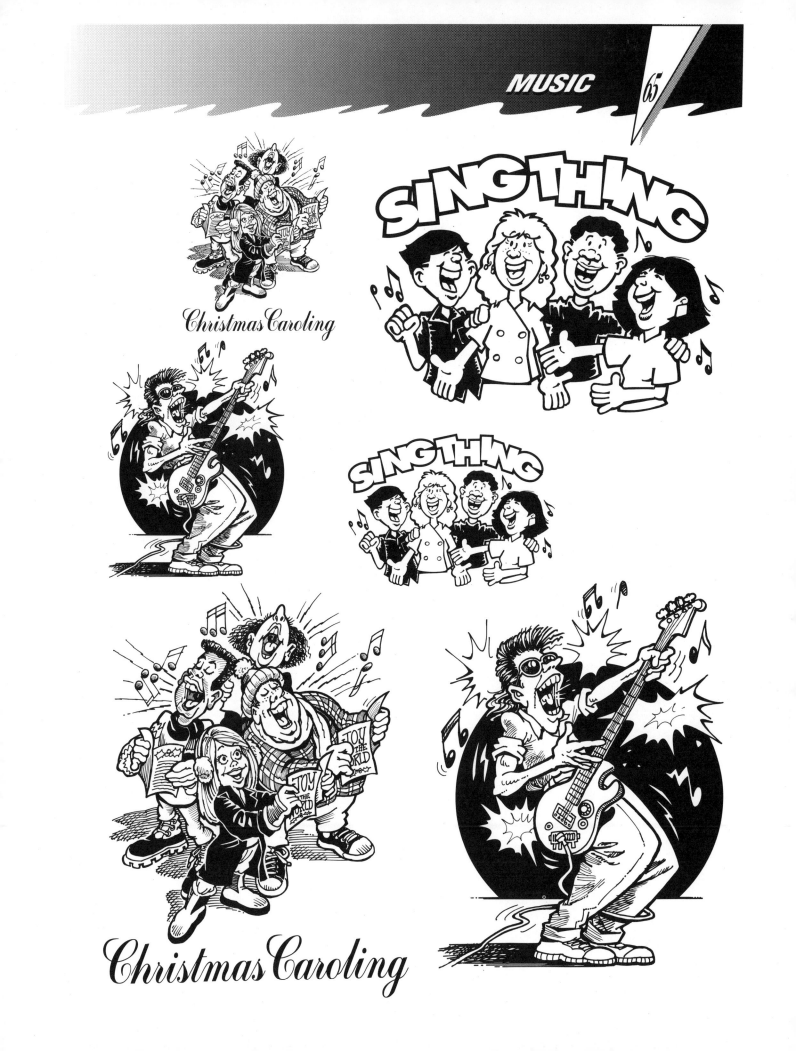

Christmas Caroling

SING THING

SING THING

Christmas Caroling

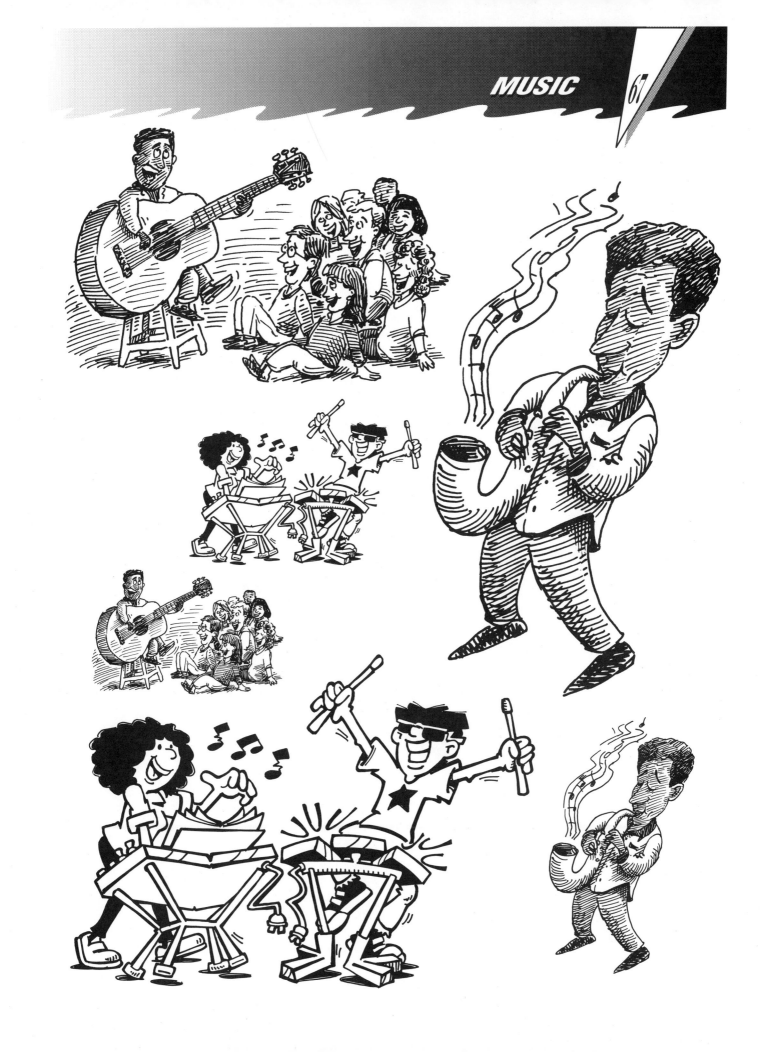

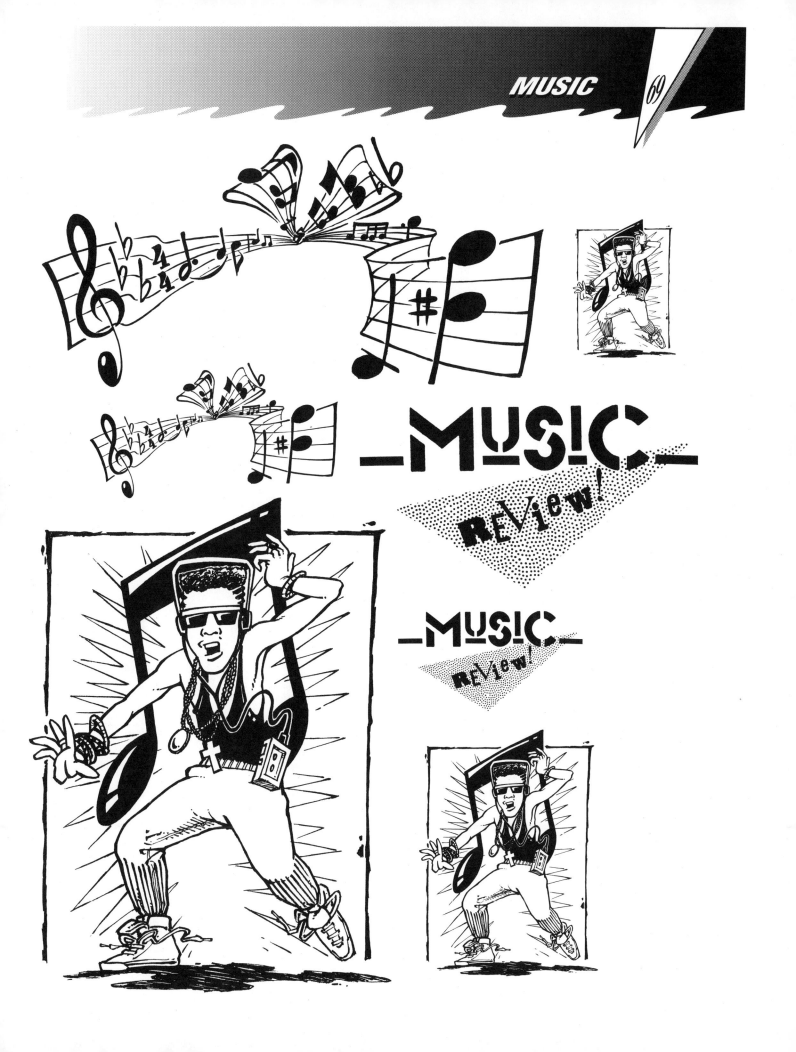

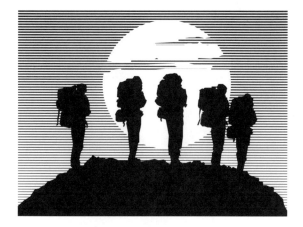

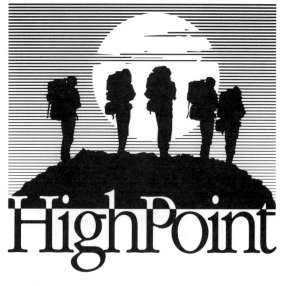

HighPoint

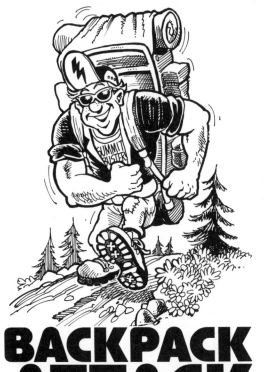

**BACKPACK
ATTACK**

BACKPACK ATTACK

HighPoint

FAIR FROLIC

FAIR FROLIC

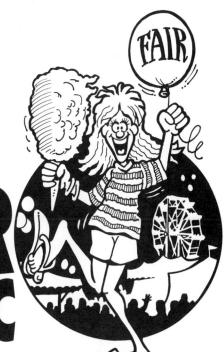

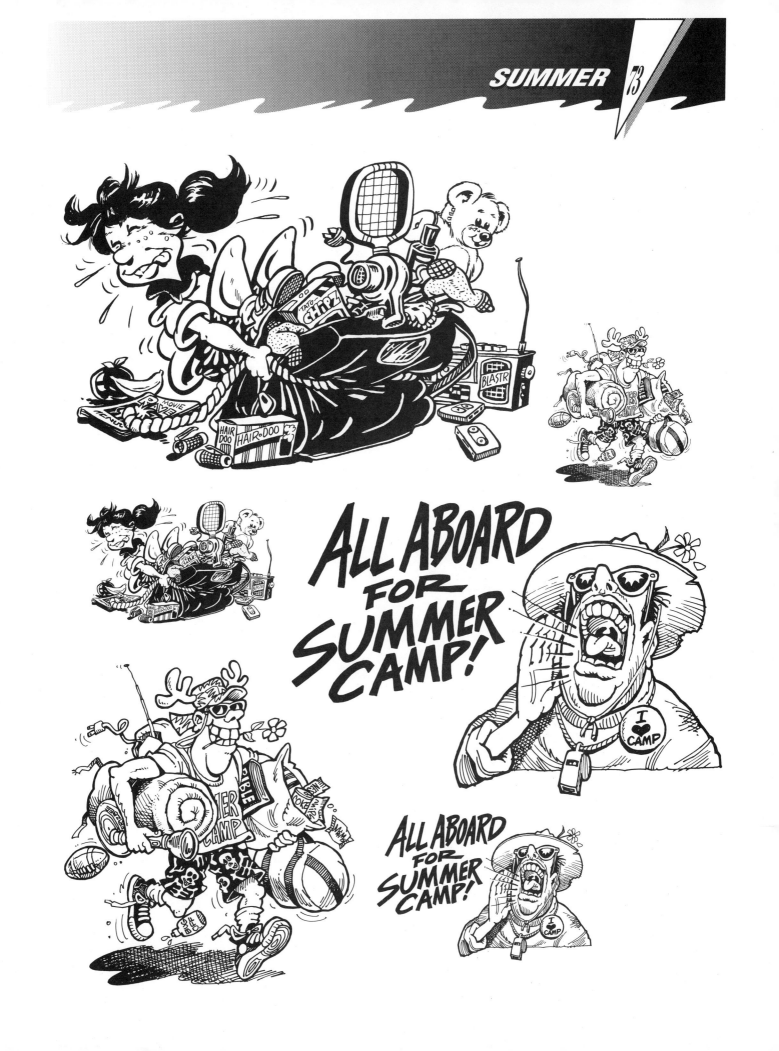

ALL ABOARD FOR SUMMER CAMP!

ALL ABOARD FOR SUMMER CAMP!

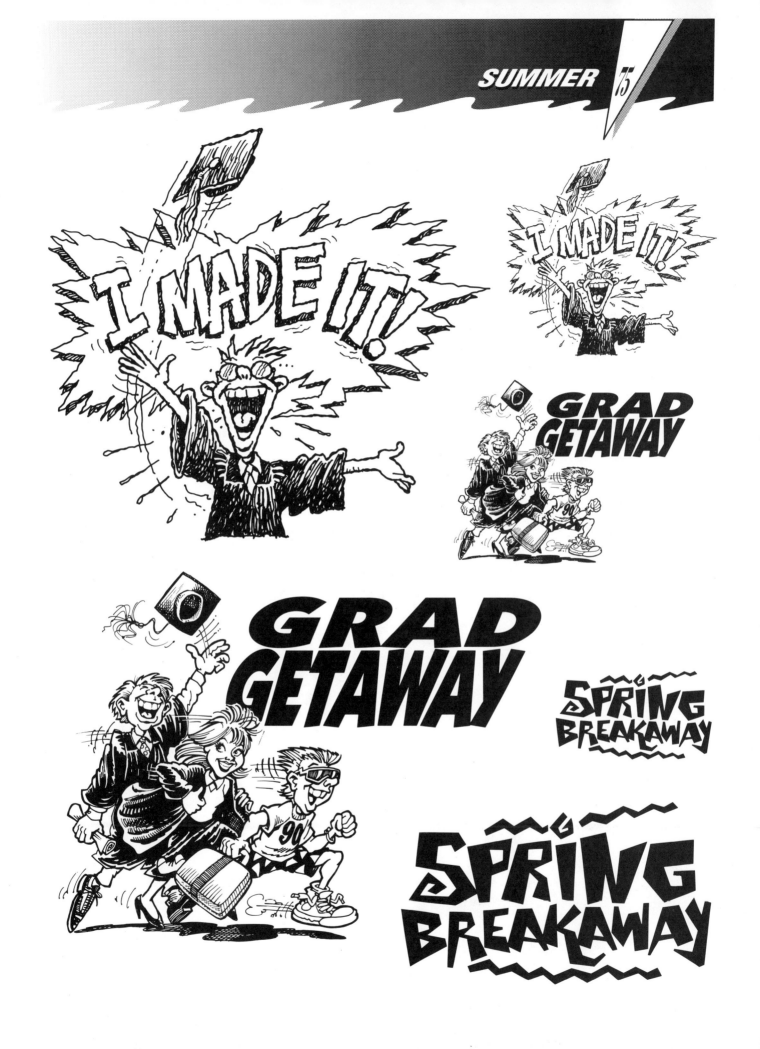

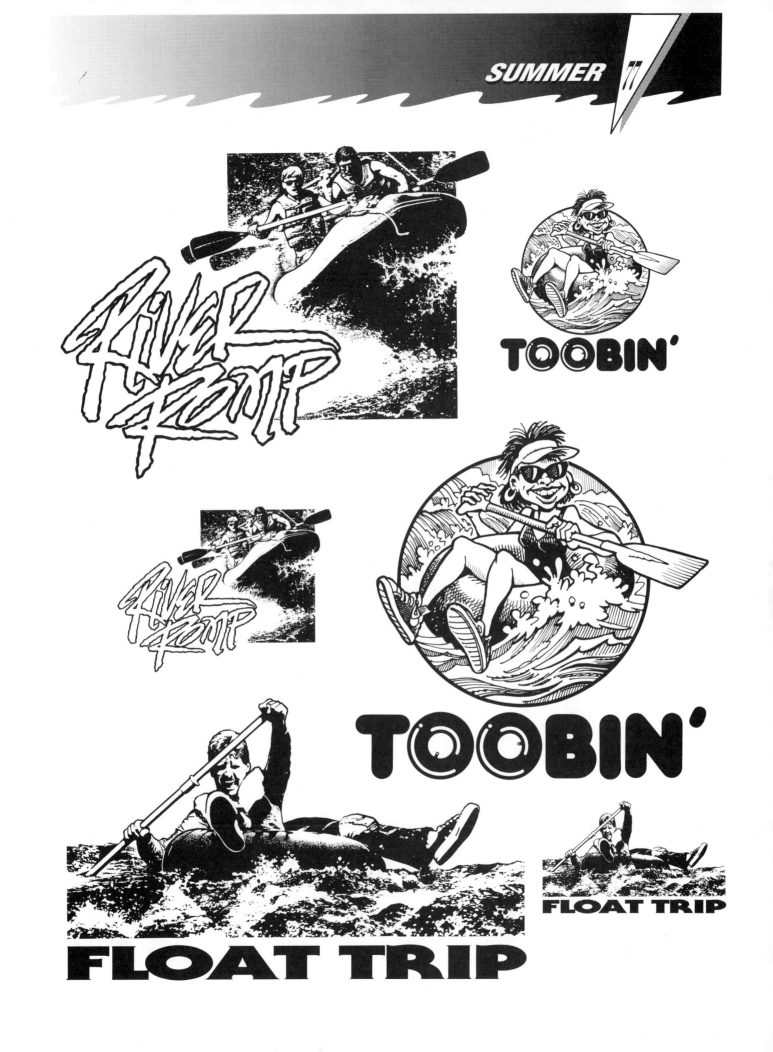

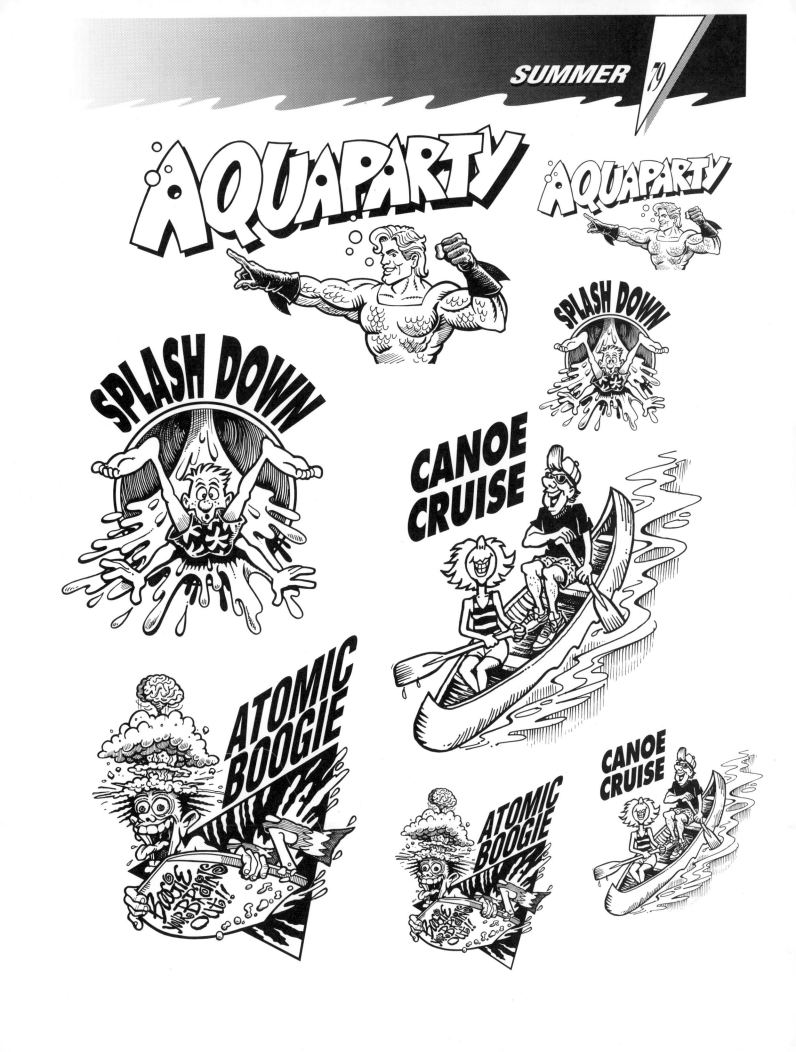

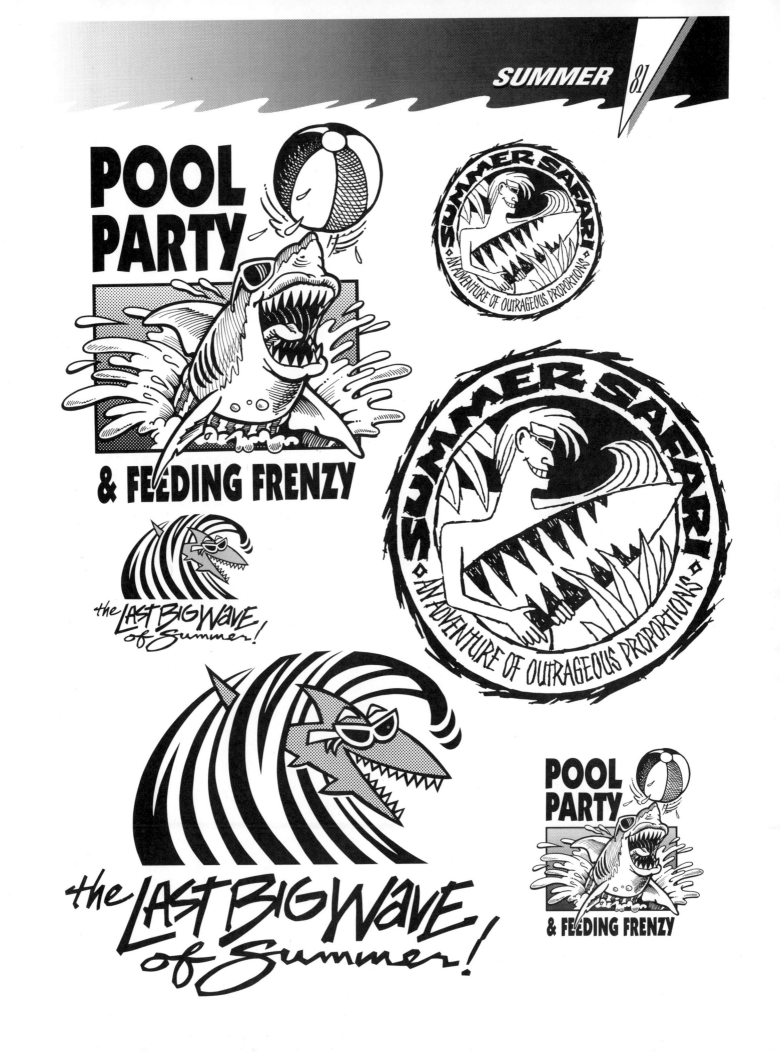

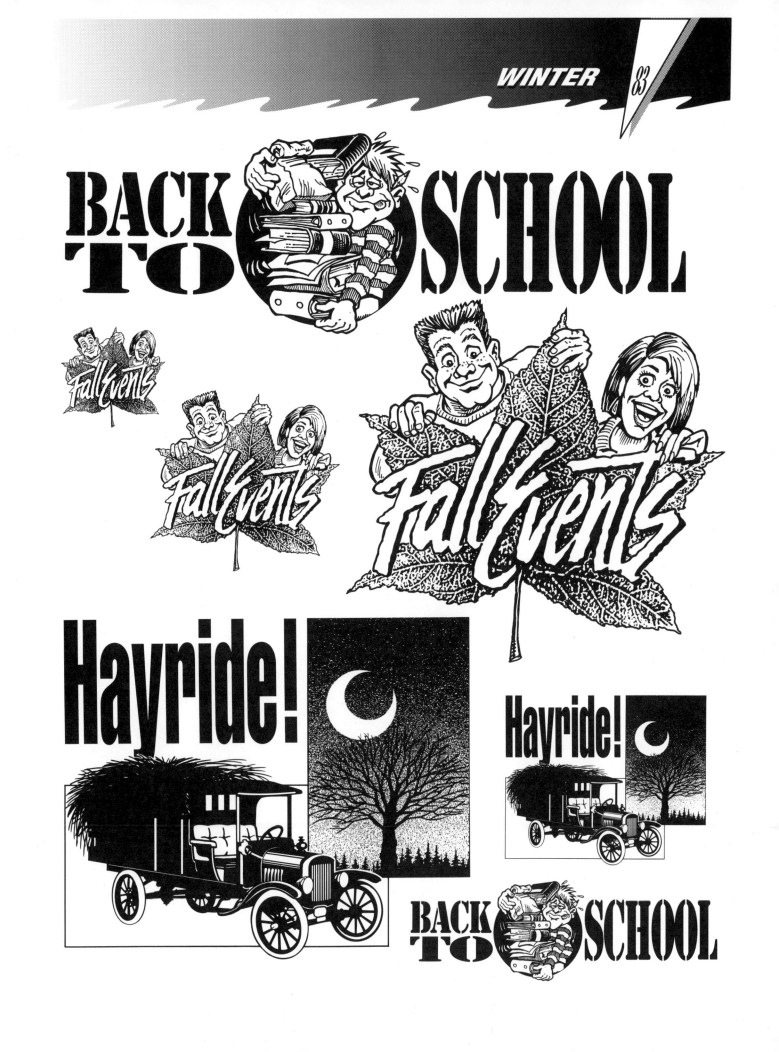

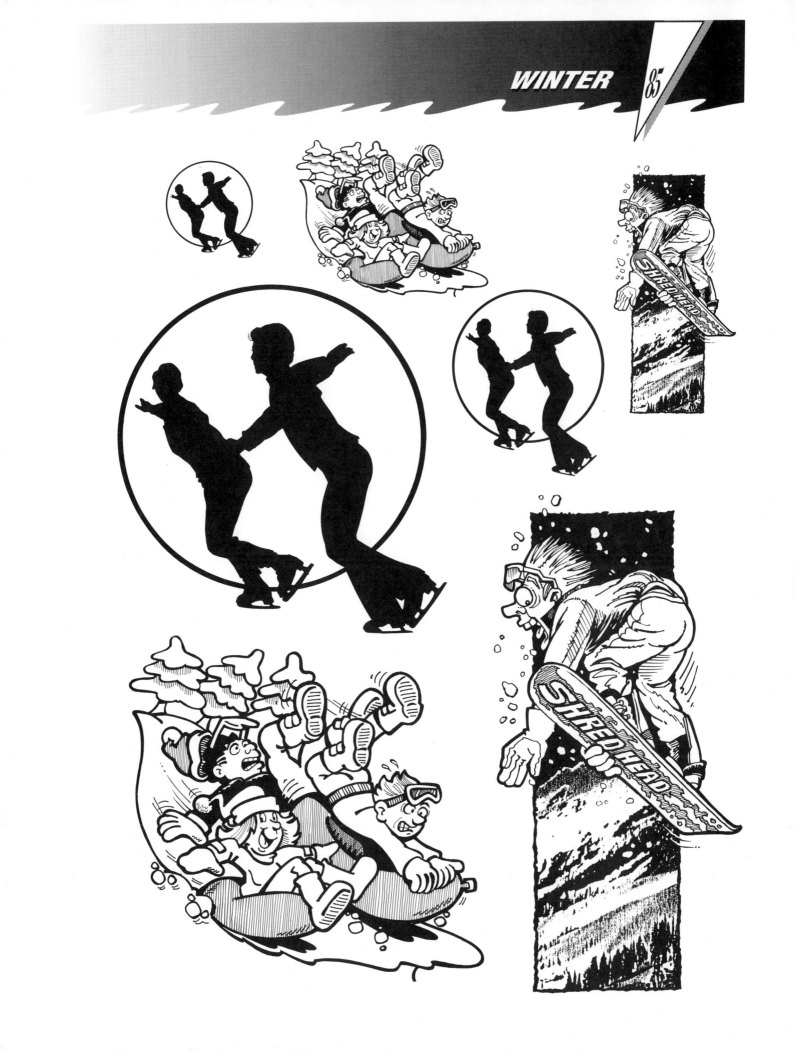

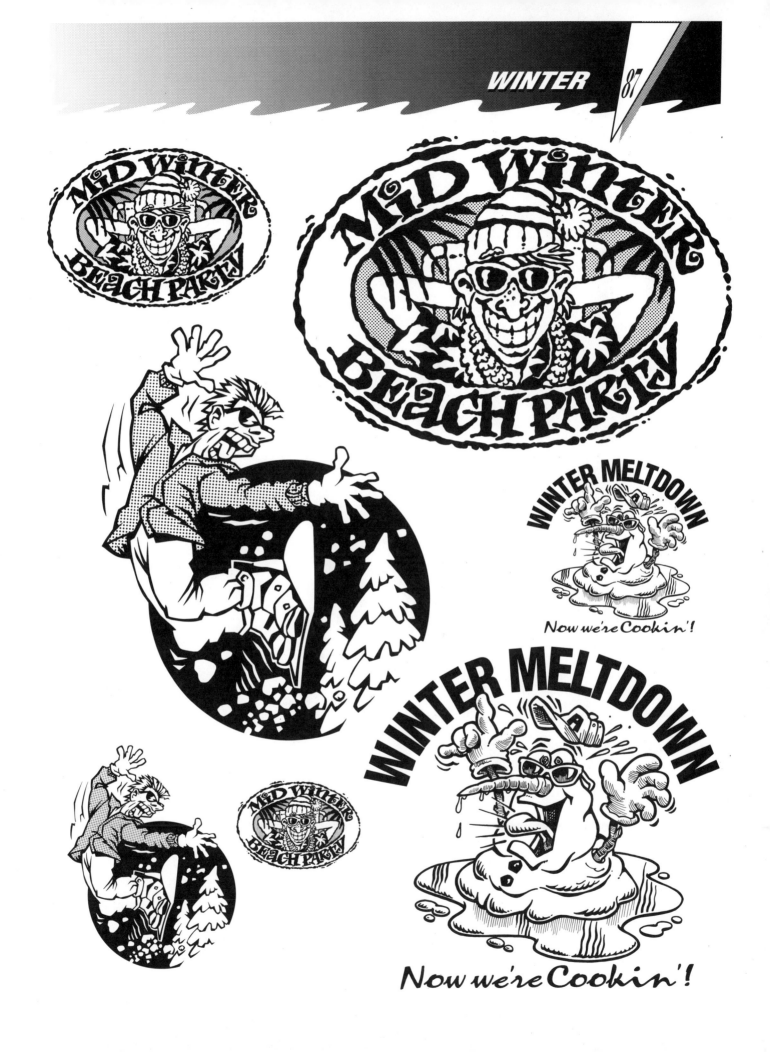

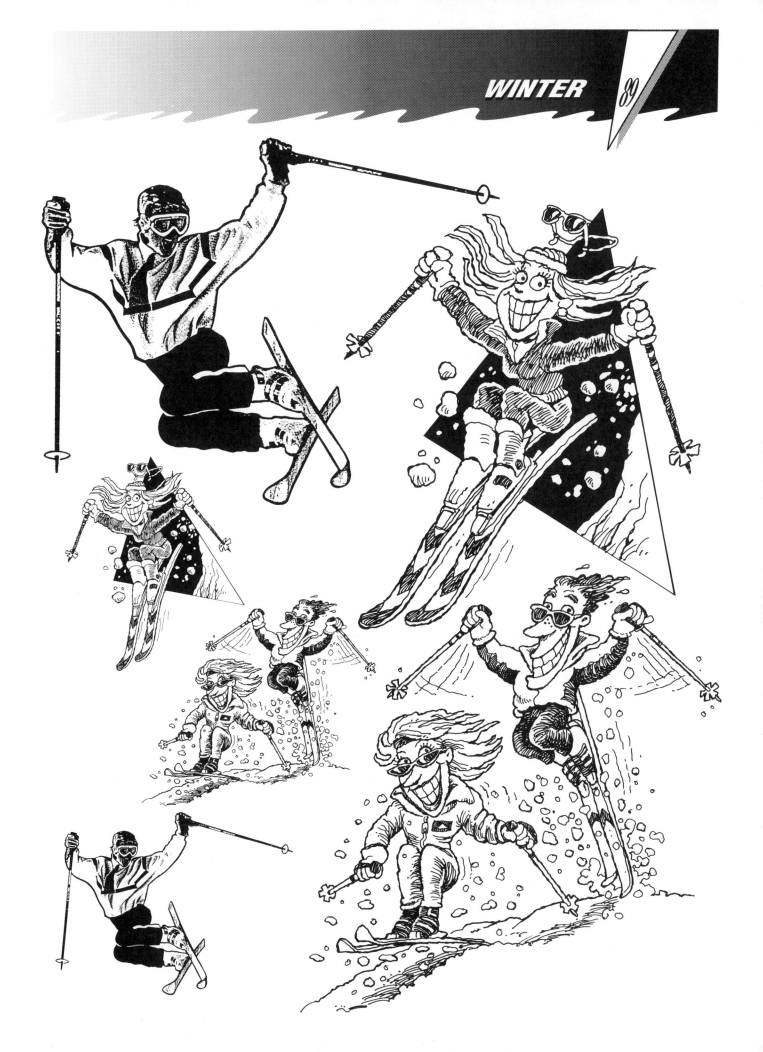

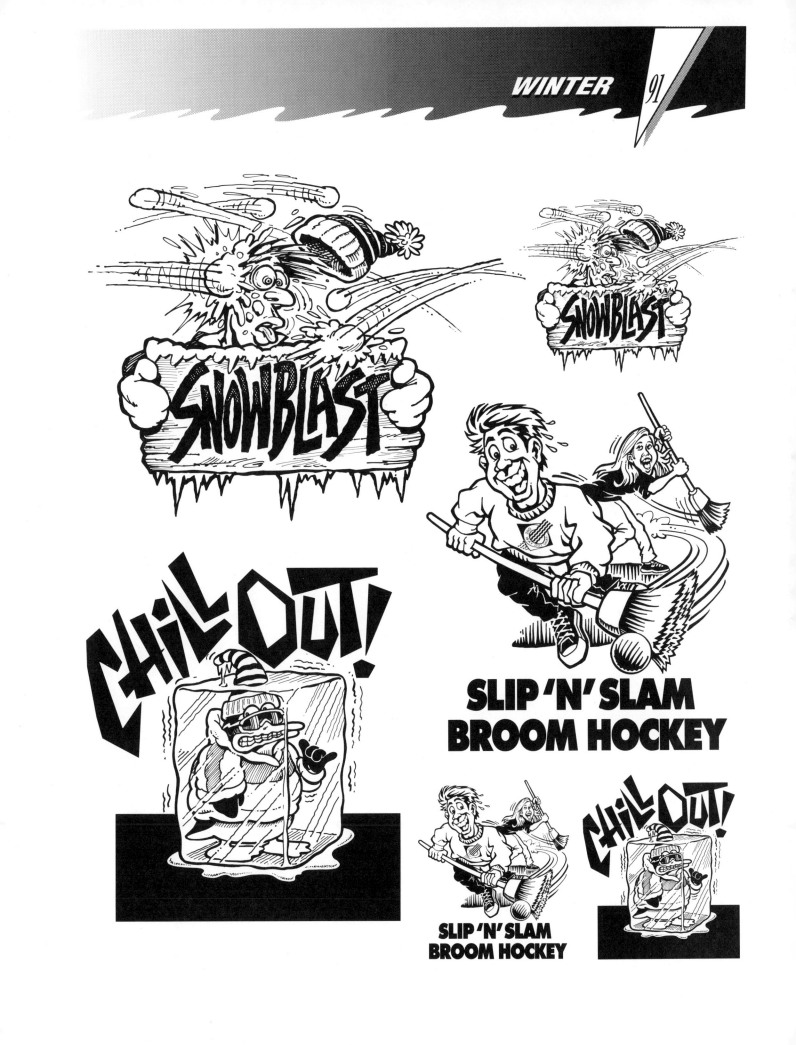

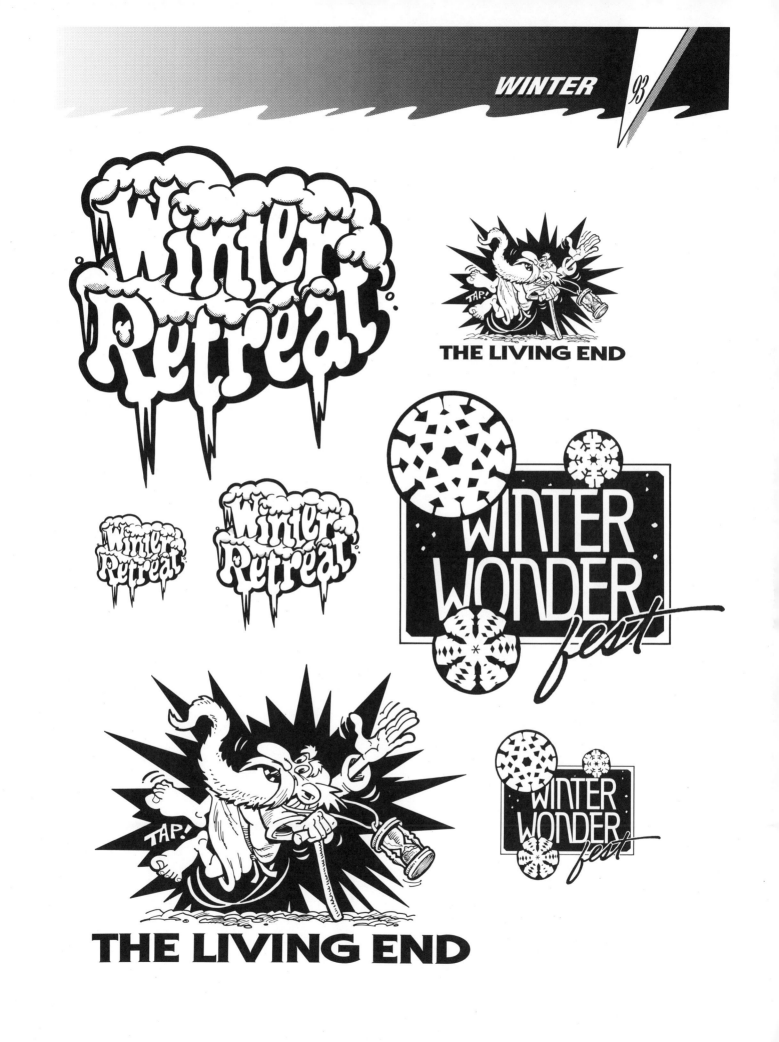